THE
DIGITAL DARKROOM
A COMPLETE GUIDE TO IMAGE PROCESSING FOR DIGITAL PHOTOGRAPHERS

RotoVision

Published and distributed by RotoVision SA
Route Suisse 9
CH-1295 Mies
Switzerland

RotoVision SA
Sales, Editorial & Production Office
Sheridan House, 112/116A Western Road
Hove BN3 1DD, UK

Tel: +44 (0)1273 72 72 68
Fax: +44 (0)1273 72 72 69
Email: sales@rotovision.com
Web: www.rotovision.com

10 9 8 7 6 5 4 3 2 1

ISBN: 2-88046-709-8

Designed by Becky Willis at Pod Design

Many thanks are due to Servane Heudiard for her
invaluable help.

Thanks, too, to Chris Weston for the use of some of
his images in this book.

Reprographics in Singapore by ProVision Pte. Ltd
Tel: +65 6334 7720
Fax: +65 6334 7721

Printing and binding in Singapore by ProVision Pte. Ltd

THE
DIGITAL DARKROOM
A COMPLETE GUIDE TO IMAGE PROCESSING FOR DIGITAL PHOTOGRAPHERS

Peter Cope and Joël Lacey

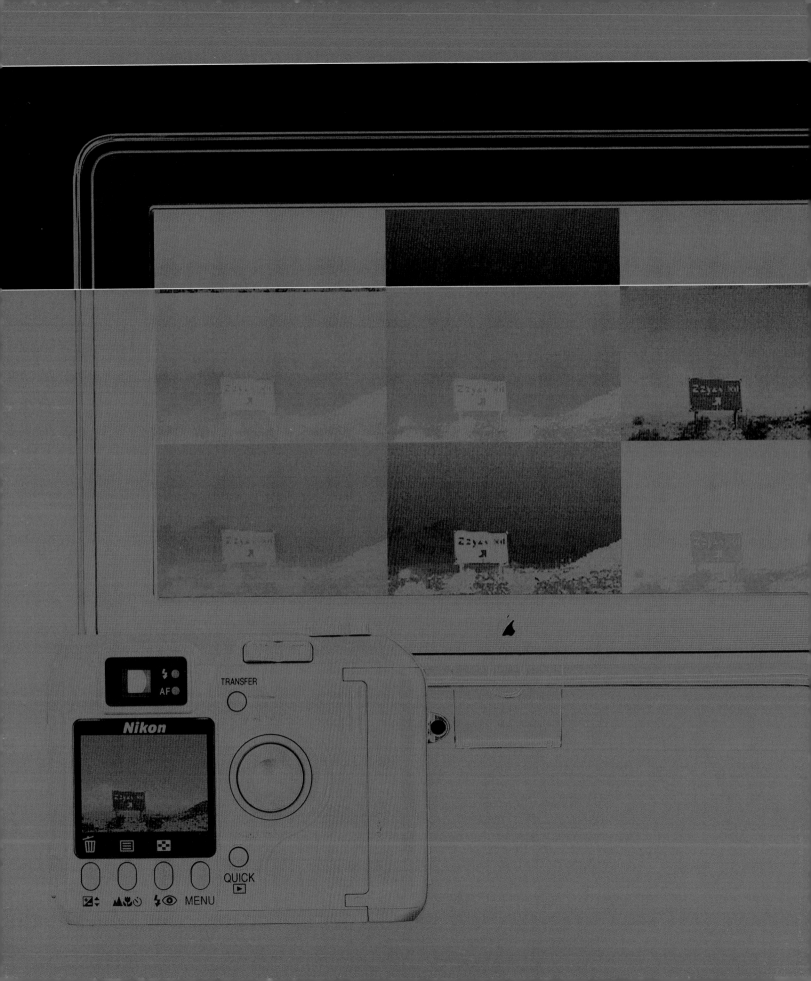

CONTENTS

INTRODUCTION

Photography has come a long way since it appeared 150 years ago. Cameras of all shapes and sizes have debuted, some surviving, others falling by the wayside. But it is in the last few years that we have witnessed the greatest changes. Digital technology—the same technology that has brought vigor and possibility to the communications worlds—has transformed photography. But this transformation has been more evolutionary than revolutionary. Were our photographic forebears to witness current trends, they would be astonished, but probably heartened to find that many of the underlying principles remain the same.

Digital cameras have made it simple to take and share photos, whether that sharing is in the form of conventional prints or digital images that we can send via email.

But it is the photographic darkroom that has seen the greatest change. The digital darkroom is a remarkable creation. No longer do you need to toil in a darkened room, exposed to deeply unpleasant chemicals. Neither do you have to devote a lot of time to the production of images. Digital photography fits in with your lifestyle.

Perhaps, most significantly, you probably have the tools to create a digital darkroom already. At its heart is your home computer—the same machine that you use to calculate the household budget or play games. There's no need to invest in specialist hardware demanded by the traditional darkroom.

In this book we'll introduce you to the tools and techniques of the digital darkroom. We'll try and stay clear of the jargon, and instead concentrate on creating great photographs. There's a saying that a little knowledge is a dangerous thing. We'll disprove that, and show how, in digital photography, a little knowledge is a powerful thing. You don't need to be an expert to produce fantastic images, just a little guidance—which is where we come in.

As you work your way through this volume we hope you'll pick up the skills that will make you a great digital photographer. You'll also learn some of the tricks that are normally the preserve of the professional.

We've based our examples on Adobe's Photoshop, which is the most widely used program on the market. It is the tool upon which many a professional photographer has staked his or her reputation. In truth, there is nothing in this book that you can't do with any of the great image-editing applications on the market, and we've certainly no personal motive for featuring Adobe products.

Whatever the software applications you choose to use with this book we hope the end result will be the same. Great pictures and inspirational artwork. We need to sound just one note of caution: once you've entered the digital darkroom, you'll find it very hard to leave...

A NOTE ON COMPUTER PLATFORMS AND SOFTWARE VERSIONS

You'll see that through this book we show computer screenshots and details using a Macintosh running OS X. But Photoshop is transparent when it comes to computer platforms. Whether you're running a Windows XP PC, a Macintosh OS X, like us, or OS 9, the contents of the dialog boxes, menu listings, and other interface details will be the same. Which platform is best? We're not even going to go near that question!

Adobe produces product updates. In general these provide added functionality to the application—rarely is a function stripped away. So we hope you'll enjoy this book whether you're using Photoshop 7, Photoshop CS, Photoshop Elements, or (as there is much that is similar) an entirely different application.

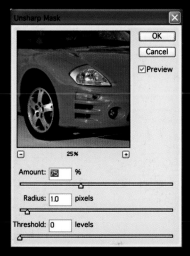
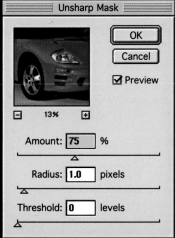

01

WHAT IS DIGITAL IMAGING?

There's no doubt about the popularity of digital photography. But for those of us who want to take a casual interest further, there seems to be something of a barrier. Like many computer-based activities it seems to have a language of its own that only knowledgeable devotees can understand. The rest of us are left at the touchline wondering.

In fact, the language of digital photography is little different from that of conventional photography. If you've used a conventional camera, you'll find much that is similar in the digital world.

But to get the best from your digital camera and to understand what is going on in the digital darkroom, deep inside your computer, we'll look at some of the concepts that underpin

digital photography. How does your humble
computer become the heart of a digital darkroom?
Do you need anything more to get better results?
These are both sensible questions.

We'll get to understand the composition of a digital
image and the importance of concepts such as
resolution and—in its digital interpretation—the
meaning of color. Most importantly, we will take a
look at quality. What makes for a good-quality
image? How do we preserve quality as we perform
all manner of manipulation on our images? You'll

THE DIGITAL IMAGE

A DIGITAL IMAGE IS A GRID MADE UP OF SQUARES, EACH CONTAINING A VALUE FOR THE COLOR IT REPRESENTS, AND ANOTHER TO INDICATE WHERE IT IS IN THE GRID. THESE SQUARES ARE KNOWN AS "PICTURE ELEMENTS", OR "PIXELS".

Rows and columns

An image made up of 100 columns and 100 rows of squares would contain 10,000 pixels. Let's imagine a square grid made up of 1,024 columns and rows of pixels. It would contain 1,048,576 pixels (1024x1024). This number of pixels is known as a "megapixel."

In the field of computing, the same terms crop up time and again: 1,024 of something is a "kilo", 1,048,576 (1024x1024) is a "mega", and 1,073,741,824 (1024x1024x1024) is a "giga". These specific numbers are used because they are round numbers in binary: the code used by computers.

In practice, manufacturers will often round these numbers down to the nearest thousand, million, or billion, to make things simpler—if less accurate. For example, they will often refer to a megapixel as 1,000,000 pixels.

Defining color

Each pixel's color is defined in terms of three values: one each for the amount of red, green, and blue that makes up the color. Each color is defined by a string of binary digits (bits), which can have a value of 0 or 1. In 8-bit images, there are 256 possible values—any number between 0 (00000000) and 255 (11111111). So, for each pixel, a color can be defined in one of 16,777,216 (256x256x256) shades.

Manipulating an image

It is worthwhile knowing these numbers for no other reason than to remember why computers are needed to perform digital imaging. Any manipulation that is one megapixel in size involves performing 1,048,576 separate mathematical functions on an 8-digit number. That is why computers need to be fast, have a lot of memory, and a lot of storage. And that is what you pay for when buying hardware.

RIGHT
You can create all kinds of wonderful effects, many of which we will explore in this book.

COLOR

WHILE THE BASIS OF DIGITAL IMAGING IS AS ABSOLUTE AS YOU CAN GET (A BIT HAS A VALUE OF EITHER 0 OR 1), IT IS VERY FLEXIBLE. ANYONE WHO HAS USED DIFFERENT CAMERA FILMS WILL KNOW THAT THEY "SEE" COLOR DIFFERENTLY, AS DO PRINTERS AND PAPERS. DIGITAL IMAGING IS MUCH THE SAME.

Getting into neutral

When it comes to scanning prints, and especially negative films, there is always an issue of getting the color "neutral". This is not as straightforward as scanner manufacturers might have you believe, but like traditional color printing, once you have the measure of film and paper you can be creative.

How do we get color images?

Although it seems strange, digital cameras see things in black and white. CCDs (Charge Coupled Devices), the sensors at the heart of most cameras and scanners, are color-blind. They give a certain output depending on the amount of light that falls on them in a given space of time (the exposure).

So where does the color come from? Each individual CCD element has a filter over it. For most cameras, this is in an alternating pattern of red/green filters on one line and another of green/blue filters on the next. What you end up with is a grid that measures the red and blue light falling on half the sensors, and the green light falling on the other. By averaging the readings from different sensor elements, it is possible to give a specific color value to a pixel in terms of red, green, and blue. This is how the color values are assigned, and the signal processing that does it is very clever. But there is a problem...

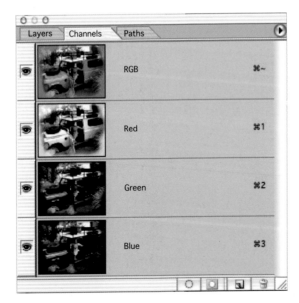

LEFT
The reason we have red green and blue sensors is that CCD pixels are color blind. They can only see light and dark. So, by combining three black and white images (each taken with a red, green, or blue filter) we get a color image. We can break an image into these constituent parts using the Channels feature in Photoshop.

LEFT
*It's surprising how
much color variation is
considered "normal".
Rather than select what
you think is correct, use
the camera's White
Balance control to
apply the correction.*

BELOW
*The CCD that actually
records the image looks
like a color tv tube.
There are red, green,
and blue sensors.*

White balance

When you shoot with film, it assumes it is shot
under daylight. CCDs do not. They make a judgement
about what they see. The problem is that it isn't
obvious to a CCD whether it is looking, say, at a red
wall under white light or a white wall under red light.
If it makes the wrong judgement, a person standing
nearby would either have a blue face, or a red one.

In order to make sense of what it sees, therefore,
a digital camera must also detect the kind of light
that is illuminating the subject and set the right
"white balance". In the context of our wall example,
it must detect the redness of the light and make the
wall white by reducing the area in the picture. It does
this by means of a function: "auto white balance".

Auto or manual?

If you have the camera set to auto white balance,
it takes a reading and decides what kind of light—
tungsten or daylight, for example—is responsible.

As well as the automatic version, there is often
a manual option. If you are shooting indoors, choose
the light bulb symbol from the white balance menu.
Under fluorescent light, select the strip light symbol.
When shooting outdoors, you are probably better off
leaving the camera to make up its own mind, unless
you are shooting a sunset, in which case you will
want to keep, not correct, the red cast, so select the
daylight white balance setting.

MEGAPIXELS AND IMAGE QUALITY

DIGITIZATION CAN BE DEFINED AS TAKING AN IMAGE COMPOSED OF DIFFERENT LEVELS OF LIGHT AND COLOR, AND TURNING IT INTO A DATA FILE WHICH REPRESENTS ALL THE LIGHT AND COLOR LEVELS IN THE FORM OF NUMBERS.

Digitization

There are two forms of digitization: capture and scanning. Digital capture is when a picture is taken with a digital camera, digital scanning when you scan an existing photograph and make it into a digital file.

Images from digital cameras

Digital cameras are available at all levels of quality and price. From fixed-lens, low-resolution models, to 14-megapixel, interchangeable-lens SLRs, and all points in between.

When you buy a digital camera, there are three things that will affect the quality of the final image: resolution, image processing, and lens quality. These can all be judged empirically—you can take pictures from one camera and compare them with others. But you can also determine a camera's quality in ways other than by judging its output. One of these is, again, resolution, but what does resolution mean in terms of the final image quality?

Resolution

Digital camera resolution can be presented in one of two ways: megapixels or image dimensions. Let's look at the latter first. An image of 1,024x768 pixels will fill an average monitor at its full size—that is, before you can start seeing the "pixelation" (the process whereby the pixels which make up the image become visible) on-screen. When you print it out, though, that same image could only be printed

at about 3½x2½in before you start to see the pixels. An image of 2,048x1,536 pixels could be printed as large as 7x5in without pixelation; while an image of 4,096x3,072 pixels could be printed as large as 13½x10¼in. You may get away with a bigger print size for some images.

In terms of megapixel count, the above stated examples are, respectively, 0.8 megapixels, 3.1 megapixels, and 12.6 megapixels (rounding a megapixel down to 1,000,000 pixels). Most consumer digital cameras are capable of up to 2.1, 3.2, 4, 5, or 7 megapixels. The more pixels, the greater the quality.

Image quality

Simply having more pixels is not necessarily going to give you better images. The quality of the lens is key, too, and can be judged by the cost of a camera.

The zoom range of the lens also plays a part. If you enlarge a half section of a digital image by 200% using software, you are halving the resolution of the image quality. However, having a zoom lens allows you to frame a more distant subject without losing resolution.

Digital cameras sometimes have a digital zoom feature, which reduces the resolution of the image as you zoom in on part of it. Don't go near it!

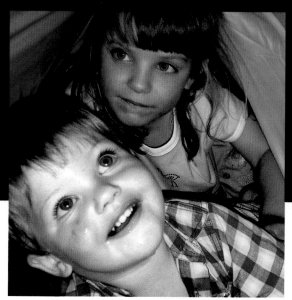

At a high resolution the color and tone in the image seems continuous. Close inspection would reveal the dots that comprise the printed image before we started to see the individual pixels.

At a lower resolution the pixel structure of the image becomes more obvious. When viewed from a distance, or if the image is small (such as on a web page) this becomes less of an issue.

At very low resolution it is still possible to associate parts of the image with the original subject but the image has no photographic value. Even at very small sizes there is no possibility of using this image for anything other than graphic impact.

Enlarging an image emphasizes the pixel structure. When part of this image is enlarged substantially it becomes pixellated and this effectively sets a ceiling to the degree of enlargement of an image that is acceptable. This is the key reason why higher and higher resolution images are consistently sought.

SETTING UP
A DIGITAL DARKROOM

A DIGITAL DARKROOM IS COMPOSED OF AN INPUT DEVICE, A COMPUTER, MONITOR, AND PRINTER, PLUS SOME SOFTWARE (THE PROGRAM THAT ENABLES YOU TO MANIPULATE IMAGES). THESE ITEMS HAVE BASIC REQUIREMENTS.

Computers

Try to buy the very latest model your budget allows. It needs to be as quick and well-specified as possible. Hardware and software manufacturers play an annoying game of leapfrog: computers get faster and more powerful, then software gets more sophisticated and requires faster processors and more built-in memory, which slows your computer down. Then the computer manufacturers make a faster, more powerful computer—and so the cycle repeats itself.

If you have an old machine (that's three years in the world of digital imaging), then you should replace or upgrade your computer's processor and memory.

Your computer should have the following features:

- CD writer/reader
- USB 2.0 or Firewire/iLink/IEEE1394 connections
- The latest processor type
- At least 1Gb (gigabyte) of short-term memory (called RAM)
- At least 120Gb of long-term storage (called a hard disk)
- A good graphics card (the electronic circuit board that turns digital numbers into on-screen images)

LEFT
The monitor is your window on the digital darkroom world.

PhotoSuite 5
File Edit View Help

All Edit Features

Overall Quality
Facial Flaws
Damaged Photos
Transform
Add Photos
Effects
Text
Create Cutout

Show Common Features

Done Editing Photo

Josh&Kate.JPG 70%

roxio

Photo Size: 10.000x6.667

Software

The software loaded on your computer determines what it can do. Some of the software deals with your computer's day-to-day running and management and provides the interface (the screen elements). This is the operating system software and it is either a flavor of Windows or the Macintosh OS.

You'll find the operating system already loaded on your computer and, for the most part, it needs no consideration. But to make the computer do practical tasks you will need to add some application software. You might already have some loaded— a copy of Microsoft Office, for example. This is the application that many use for word-processing and spreadsheets. You will probably have Internet browsing software.

For image-editing, you'll need—naturally enough— image-editing software. This is an application (or several), that can be used to perform image edits and manipulations. As we've already mentioned, the application we've used in this book is Adobe's

Photoshop, but there are alternatives that offer similar functionality, including Photoshop's sibling Photoshop Elements (we compare several top products on pages 166–169).

You may find, as your experience grows, that you'll need to add to your software inventory. There are specialist image-editing applications that deal with specific areas of image-generation—panoramas, for example. Photoshop Elements can create simple panoramic images from individual images, but for more complex views or immersive panoramas on websites, you'll need something more. Likewise with creating websites: all the top applications provide tools for website-creation, but if you're serious about it and want to market your photos over the Web, you'll need appropriate software.

Scanners

There are two kinds of people who want a digital darkroom: digital and *hybrid* digital photographers. The former uses a digital camera, and the latter has come from film photography with an archive full of photographic memories that he or she would like to manipulate or reprint. As far as the difference in requirements is concerned, there is one: the need for a scanner for the film-photography migrants.

Scanners come in three basic forms: print scanners, film scanners, and hybrid (both film and print) scanners. If you have 35mm slides or negatives that you want to convert to digital, then a dedicated film scanner is best. This should have an input resolution of 2,700ppi (pixels per inch) or more—the scanner's resolution will be clearly marked on its literature. If you have a lot of prints and no slides, then a print scanner with a scan area of foolscap (A4 size) will suit you better. All print scanners on the market, with the possible exception of the very cheapest, will be more than adequate for your needs. If you have both film and prints to scan, you could choose to buy one of each scanner (which will be a better solution from a quality point of view), but you could also think about a hybrid scanner. This is a print scanner with an attachment for scanning negatives and slides. Hybrid scanners are a good choice if you have medium-format negatives or slides and don't want to spend money on a medium-format scanner.

ABOVE
Slide scanners make it a simple process to scan your 35mm transparencies. Alternatively, use a flatbed scanner with a transparency hood—this will perform exactly the same function.

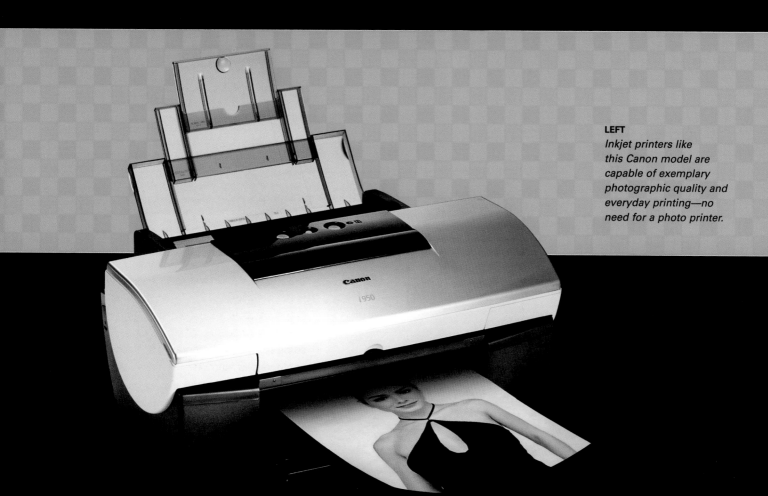

LEFT
*Inkjet printers like
this Canon model are
capable of exemplary
photographic quality and
everyday printing—no
need for a photo printer.*

Printing

The Web continues to grow and, in some areas, dominates digital photography, but for most of us there is nothing to compare with a photographic print. The good news is that, today, many computer printers are capable of producing photographic-quality prints. And this includes those ink-jet printers that you use for printing letters, or whatever.

You'll achieve the best-quality prints by using the right media. The printer manufacturers offer a range of printing papers that emulate the surfaces found in traditional photographic papers, including heavyweight glossy, matte, and pearlized finishes.

The best results come from printers that are designed to deliver photographic results (as well as conventional printing). These have six-color printing (rather than four-color in the budget models), and specialized inks that are matched to the printing. When you use the recommended combination of papers and inks, the printer manufacturer guarantees print quality and permanence on a par with (or sometimes greater) than that of conventional printing.

THE DIGITAL PROCESS

WITH THE BUILDING BLOCKS OF DIGITAL IMAGING OUT OF THE WAY, WE LOOK AT HOW THEY WORK TOGETHER: THE DIGITAL-IMAGING PROCESS. THE THREE DISTINCT ELEMENTS ARE INPUT, PROCESSING, AND OUTPUT.

IMGP0034.JPG IMGP0035.JPG IMGP0038.JPG IMGP0039.JPG

IMGP0046.JPG IMGP0047.JPG IMGP0048.JPG IMGP0049.JPG

IMGP0050.JPG IMGP0051.JPG IMGP0053.JPG IMGP0054.JPG

IMGP0062.JPG IMGP0063.JPG IMGP0064.JPG IMGP0065.JPG

IMGP0066.JPG IMGP0067.JPG IMGP0068.JPG IMGP0070.JPG

IMGP0071.JPG IMGP0072.JPG IMGP0073.JPG IMGP0074.JPG

Input

If you are a digital-camera user, there is a strong argument for getting your pictures from the camera to the computer as soon as possible. It frees up space on your digital camera memory cards and it eliminates the chance of losing your images.

As far as scanning goes, it makes sense from a time-management point of view to scan a batch of images at one time and then come back at a later stage to perform your processing on them.

While you can copy pictures from a camera to a computer, or scan in a selection of images called IMAGE 0001, 0002, etc., this is not the best practice.

Labeling files

One of the great things about computer files (including image files) is that you can search for them in many ways. One of these is by means of an "image browser." This show you what is really a contact sheet of your thumbnail images. This is great if you only have 20 images on your computer—you can look at them all on one screen and quickly pick out which image you want to edit. But what if you have 200 images? You could get the browser to show smaller versions, but then it is harder to identify them. And what if, after a couple of years, you have 2,000? It would take ages to go through them all by eye. What's the solution?

There are two solutions, both involving names. As I said earlier, there are a number of ways to find computer files, and the most successful is by file name or partial file name. Wouldn't it be great to find all your pictures of someone, or those which contain a specific person, by simply entering their name in

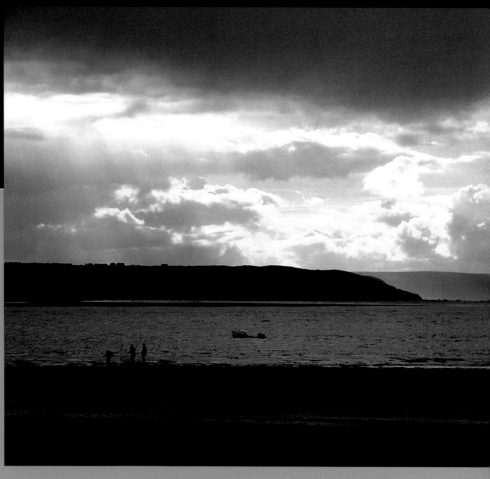

the computer's file search facility? This you can do, but only by making sure you name the relevant person in your image's filename when you save it from your scanner or digital camera to your computer. Let's say you had a picture of your daughter, Jenny. A portrait at the beach might be saved as "JenBeach".

Another recommended practice is to file your pictures in specific folders, by creating a new folder for each batch of scans, or memory card download. For a set of pictures from a French holiday you could name a folder, say, "France03", and put that in a folder called "Holidays". To find a picture of Jenny at the beach, then, you could search for "Jen", for "Beach", or even for "France", and still find the image with one search.

TOP LEFT
When you give an image a new name, you'll see that name reproduced in the header whenever the image is opened. It makes sense to give images meaningful names to make your searches easier.

FACING OPPOSITE
Good cataloging and storage is essential. Most digital cameras include software that will download your images and produce a catalog of thumbnails to make identification simple.

BOTTOM LEFT
The latest operating systems, like Windows XP, can display the contents of a folder as thumbnails. This is great for identifying small collections of images, but is less effective when your collection grows.

ABOVE
Good naming and cataloging is essential when you have multiple images that differ only very slightly. This image, above, was one of a series the photographer took several, different images with the people on the beach. By assigning appropriate filenames she was able quickly to return to the relevant images when searching.

FILE FORMATS

DIGITAL CAMERAS HAVE THREE MAIN FILE FORMATS: JPEG, TIFF, AND RAW. A CAMERA THAT ALLOWS YOU TO SAVE IN UNCOMPRESSED TIFF MODE OR RAW MODE IS LIKELY TO BE A HIGHER QUALITY THAN THOSE THAT ONLY OFFER JPEG FORMAT. SO, WHICH IS BEST FOR YOU?

Saving files in-camera

The options a camera gives you when saving a file is normally a good indicator of its quality. Digital cameras have three main file formats: JPEG, TIFF, and RAW. A camera that allows you to save in uncompressed TIFF mode or RAW mode is likely to be a higher quality than those that only offer JPEG format. If a manufacturer allows you to save an image in the best form for quality retention is not thinking about squeezing pictures on a memory card.

Memory cards are solid-state hard drives (they have no moving parts). They store images even when there is no power going to them. The bigger the capacity of the card (16Mb, 32Mb, 64Mb, or up to 1Gb), the more pictures you can take before you need to delete or transfer images to your computer.

Computer formats

Let's look at the file formats you should use to save your pictures on your computer. If you have the space on your memory card, you should save your pictures as RAW or TIFF files. Even if you have saved your pictures as JPEGs (compressed files) on your digital camera's memory card, there is no reason to save these images as JPEGs on your computer's hard drive. Your hard drive will probably have over 300 times as much room as your camera's memory card —perhaps more—so space isn't an issue. Plus, if you perform any kind of processing on the image before saving it, any artefacts (unwanted effects) from that processing will be heightened by compressing the image as a JPEG.

So which file formats should you use? If you are using an Adobe image-manipulation package (Adobe Photoshop or Photoshop Elements), then the PSD (Photoshop document) format is best. This is an uncompressed format which allows you to use layers, and also gives a smaller file size than TIFFs, the other standard uncompressed format. If you stored your camera files as RAW on the digital memory card, then RAW is the best format to use for long-term storage with maximum quality-retention. If you are inputting from a film or print scanner, save your images as PSDs or TIFFs.

BELOW
When you take a digital photo most cameras record the scene and details about the shot itself. This includes exposure details, camera settings, date, time, etc. You can display these details using the software supplied with the camera.

LEFT
Photoshop can display EXIF (extra information) data. Some cameras record extra information, and this can also be displayed. Use EXIF data as an aide-memoire.

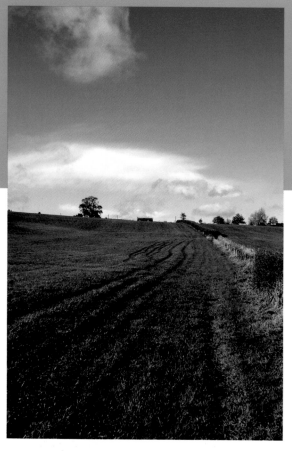
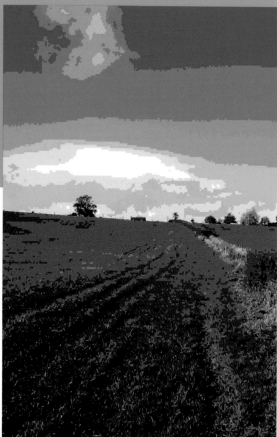

LEFT
Compressing your images saves disk space and enables a file to be sent by email. However, heavy compression can compromise the image quality. Here, the color range has been reduced and resulted in blocked color. This effect, known as "Posterization," can sometimes be used to creative effect.

Keeping an original

The most important thing is to have an "original" version of your image, saved before you manipulate it. Any digital processing will mean a loss of data. If you don't have an original copy, then you won't be able to do an improved manipulation of an original image. As far as scans are concerned, some processing will take place as the image is being processed by the scanner's driver software.

Files from other sources

While most images originate from digital cameras and scans, some come from other sources: CDs, perhaps from a photo-processor, emailed images, or digital movie stills. The common factor between these and the ones from your digital camera or scans is to ensure that no detail is lost during the saving process, thus, again, the image file formats of choice are the PSD, and the uncompressed TIFF.

TIPS

■ The main file formats—JPEG, TIFF, and RAW—are written in capital letters. JPEG stands for Joint Photographic Experts Group, TIFF for Tagged Image File Format, and RAW is simply a descriptive name.

■ While a TIFF is known as an uncompressed file format, it can be compressed. This won't affect image quality (as it will with JPEGs), but it will affect how many people can read your images.

PRINTING

MANUFACTURERS TRY TO PERSUADE US THAT WE WANT TO LOOK AT OUR PICTURES ON-SCREEN.
HOWEVER, FOR MANY, AN IMAGE IS ONLY A PHOTOGRAPH WHEN IT IS ON PAPER. SO, HOW DO YOU
GET AN IMAGE FROM SCREEN TO PAPER? THE MOST POPULAR ANSWER IS WITH AN INK-JET PRINTER.

Ink-jet printers

The way ink-jet printers work is to spray tiny droplets
of colored inks onto specially coated, bright-white
paper. The inks spread a little and, by a combination
of the different inks and the whiteness of the paper
showing through the gaps between the inks, millions
of different-colored shades can be created.

Some printers use four ink colors: cyan (turquoise),
magenta (shocking pink), yellow, and black. This (for
historical reasons) is known as CMYK. Sophisticated
printers use six colors—CMYK, plus lighter versions
of magenta and cyan for subtler rendition.

As well as the number of inks used, the number
and size of ink droplets also has a bearing on quality
and the level of "photo-realism" an ink-jet printer
can produce.

Judging quality

The universal measure for describing printer output
is dpi (dots per inch)—that is, the number of tiny
individual droplets of ink that a printer can lay down
in an inch. Theoretically, the more dots the better.
But the more drops you lay down, the smaller they
have to be, or no white from the paper will show
through. It is not uncommon for an ink-jet printer to
be able to lay down 4,800 dots per inch (dpi) or,
rather, one drop every $1/4,800$ in. Why do we need
such fine droplets separated by such tiny differences?
When the size of the ink-jet droplet falls below that
visible to the naked eye, we no longer see the
droplets, we only see the image the droplets
collectively go together to create.

RIGHT AND FAR RIGHT
*Every printer comes with
it's own printer driver
software. This enables you
to configure the printer to
deliver the best results for
a project. You can select
either fast, low-resolution
copies, right, or choose
the printing characteristics
to take best advantage
of specialist paper types,
far right.*

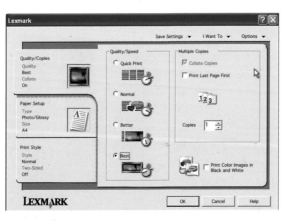

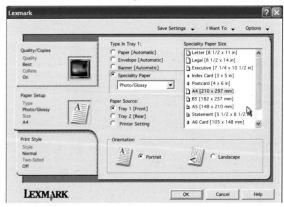

LEFT
This partially complete ink-jet print shows how an image is built up with progressive scans by the printing head. Each pass of the print head adds further fine dots to build up the image.

BELOW
In this partially complete section of the print it is easy to see the dots. Ultimately, additional passes of the print head would produce virtually continuous color and tone across this area.

Printing real photographs

An alternative to home ink-jet printing is the printing of digital images onto photographic paper at a photo-processor. This has a couple of advantages over the home version: lower cost of multiple prints, and photographic look—not a scientific point but one impossible to define. It is the "feel" of the colors, the way they merge in a natural way that ink-jet printers are only now beginning to emulate. As the silver halide grains and the dye clumps to which they are attached are randomly distributed, images on photographic paper have a smoothness of tone

extraordinarily hard to achieve with ink-jet printers. Light is projected onto photographic paper, which is then processed in chemicals in the same way as prints from film negatives.

DIGITAL IMAGE QUALITY

IMAGE QUALITY IS EASY TO DESCRIBE SUBJECTIVELY. IF SOMEONE SAYS "I LIKE IT", EVERYONE KNOWS WHAT THEY MEAN. BUT THIS TYPE OF DESCRIPTION ISN'T VERY HELPFUL WHEN YOU WANT TO DETERMINE WHY SOMETHING IS GOOD QUALITY.

Getting objective

A more objective measure would be less meaningful to the layman, but more useful to the digital imager. More than this, it will help make high-quality shots more achievable and repeatable.

There are four main measures of image quality—image resolution, image contrast and exposure, image sharpness, and color balance.

Image resolution

The resolution of an image is not just the number of pixels that combine to create it, but how much detail has been captured. The resolving power of a digital-imaging system is not just about CCD sensors. With digital cameras, it is also about lens quality, camera shake, and subject movement, but once your image is on the computer there is little you can do about it.

With scanners, film grain size, optical array quality, light sources, and oversampling can also impact on resolution. Often, you are limited by your scanner, and that is it, except for the concept of oversampling. If you have a camera that produces a digital image of 6 megapixels, and a scanner that has a scanning resolution of 2,000 pixels per inch (ppi), they will both deliver a 6-megapixel image. However, the digital camera image will have better resolution.

To correctly capture a film image's detail, you must oversample by having a higher-resolution scan. The scanner has to create an image that can capture each blob of dye in the film sharply in order to produce an image of equal quality. To achieve this, you need to have more than one pixel for each blob of dye. The number of pixels per piece of detail is called the "Nyquist frequency". To a degree, you can never scan at too high a resolution.

LEFT
This shot depends on precise timing and a high shutter speed to capture the biker in mid flight. The impact also comes from a high tonal range—from blackest blacks to the whitest whites.

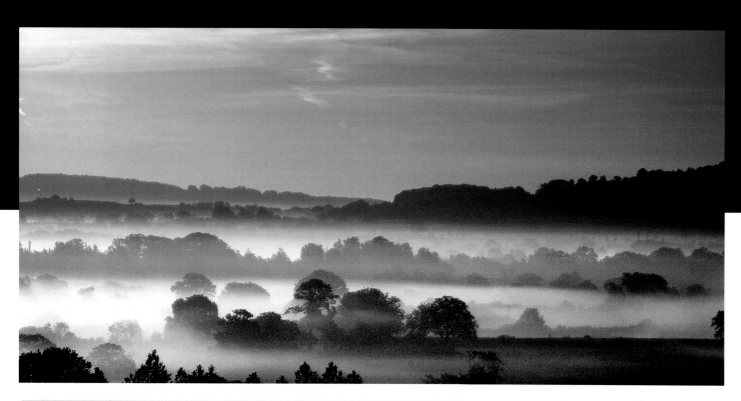

ABOVE
A more limited range of tones and restricted colors are successful in moody landscapes such as this. A blue filter helps with the mood, with the color balance set to manual to prevent the color from being neutralized.

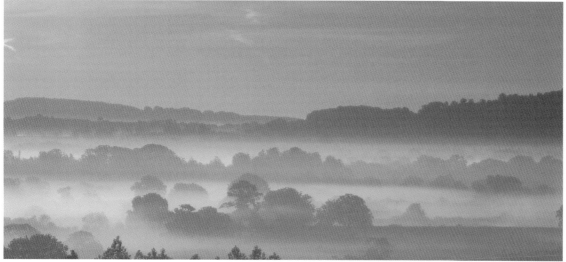

LEFT
This shot of the same scene (without the filter) doesn't have the same dynamism. Without whites and blacks, the result is "flatter". This may reflect the actual scene, but we get more satisfaction by manipulating the tonal range.

Image contrast and exposure

Well-exposed digital images, like well-exposed film images, should feature both a deep black and a true white. This is rarely the case, and images can be a little insipid. Thankfully, image contrast is easily correctable.

Low-contrast images will go from a light to a dark gray. Images with too much contrast will have clear whites and deep blacks, but little in between. It is easier to increase the contrast of a digital image than decrease it. Similarly, it is easier to lighten a black area and retain detail than it is to darken a white area. In short, if you don't have a perfectly exposed, medium-contrast image, it's better to have a dark, low-contrast image than a light, high-contrast one.

 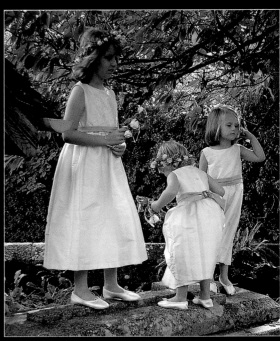

Image sharpness

Image sharpness is not the same as resolution. In digital-imaging, sharpness and sharpening refer to edge contrast—the contrast in tone between the pixel-forming part of, for example, a twig and the pixel next to it that represents the sky. The higher the edge contrast, the "sharper" an image.

Color balance

Digital images are made up of combinations of the primary colors. It is vital to balance the amount of each to make the image look natural. Adjusting the color balance will do just that, making the image look more realistic.

Image size

You can define the size of a digital image as:

• The total number of pixels it has, for example: 6 megapixels;
• How many pixels it has in each dimension, for example: 3,000x2,000 pixels;
• Or the physical size at a given output resolution, for example the picture will print out at 10x6⅔in at 300 pixels per inch (ppi).

All three examples are for the same image, but the most useful is the last, because it lets you see how large you can print an image, without the quality being compromised. The 300ppi setting is a standard for resolution at which, when an image is printed, you will not be able to make out the component pixels. It is sometimes possible to print at lower resolutions and achieve acceptable pictures.

Interpolation

What do you do if your image has too few pixels in it to print at the desired size? We deal with printing solutions on page 144, but there is also "interpolation".

Interpolation is, essentially, guesswork. The software looks at two pixels and guesses what color they would be if they were four pixels. It is an imperfect system, because if, for example, it looks at an image of an eyelash, it doesn't know what it is, only that the pixel in the eyelash is dark, and the one next to it is skin-toned. It smoothes the difference between them, and introduces a pixel that is halfway between the two. The interpolated image will seem to have higher-resolution than its original, but it does not have more detail, only pixels.

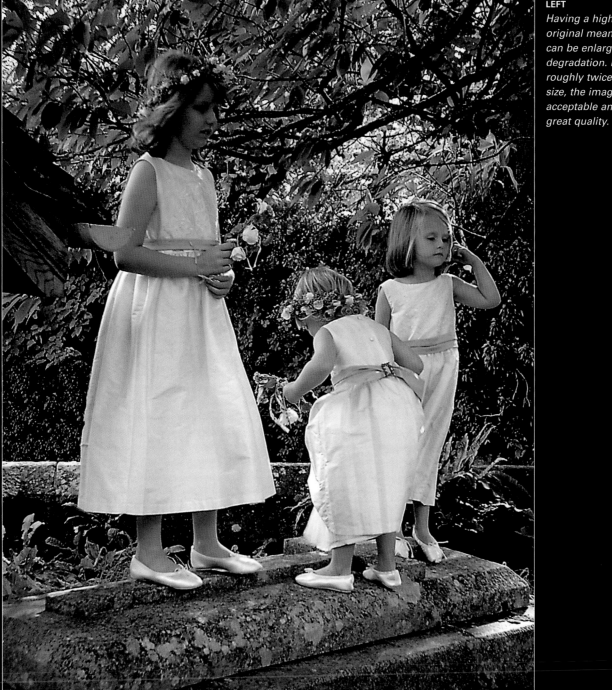

LEFT

Having a high-resolution original means the image can be enlarged without degradation. Here, at roughly twice the original size, the image is perfectly acceptable and offers great quality.

02

DIGITAL DARKROOM BASICS

In many respects modern computer systems provide turnkey solutions. Turn them on and in a couple of mouse clicks you are ready to go. Yes, it really is that simple—almost. To get the best from the digital darkroom you need to spend a little time making sure that your computer and the software you've chosen is working optimally. Now you have the information about the theoretical side of digital imaging, it's time to get into the digital darkroom proper.

First we'll look at how to set up your digital-imaging application, then examine some of the key techniques you'll need for the projects in this book.

We need to take a look too at what digital image-manipulation is capable of and, perhaps more significantly, what it is not.

It's useful to think of your image-editing application as a great tool chest. Inside are all the tools that you need to do virtually anything to an image. But, there are some tools that you'll use every day, others more rarely. We'll take a look inside this virtual tool chest and examine all the hot—and not so hot—tools inside.

WHAT'S POSSIBLE, AND WHAT'S NOT

DIGITAL IMAGING IS SEEN AS A CURE FOR ALL PHOTOGRAPHIC ILLS. THERE ARE SOME POWERFUL TOOLS IN PHOTOSHOP BUT IT IS NOT ALWAYS THE PANACEA THAT WE WOULD LIKE IT TO BE, AND WE NEED TO FAMILIARIZE OURSELVES WITH THE REAL POTENTIAL OF THE APPLICATION.

Making improvements

Digital-imaging applications can improve your images, but they cannot put right errors in the originals. This is perhaps nowhere better seen than with the vexed question of sharpening. It is commonly understood that digital software can restore sharpness to a blurred image. So, if your photographs are blighted by camera shake a couple of clicks will sort everything out. Unfortunately, it can't. You can give the image a perceived sense of sharpness but you can't put back the critical elements—the detailing—that was not there in the first place.

However, there is no doubt that with a little skill and imagination, you can sometimes create something that is better than the original picture. To do that requires a flash of inspiration. Over the next pages, we hope to give you the occasional spark. Add your own images and inspiration and perhaps that spark will flare to a flash.

There are three things to bear in mind when manipulating images:

- When highlight detail has whited out, you can't get it back apart from to draw it in, pixel by pixel.
- It is possible to increase the number of pixels in an image, but it is never possible to increase the amount of detail in an image by doing so.
- Virtually every thing you do to a digital image causes some information to be lost.

The phrase "less is more" does not always apply to digital imaging, but the law of diminishing returns does. The first ten minutes you spend on an image will achieve more than the second ten, and so on.

On a safety note, you really can't save your work too often. Computers are infamous for freezing or crashing (in other words, to temporarily stop working) just at the moment when you've finished a huge piece of work, but the second before you can save it. Save the file after you have finished any part of a manipulation.

TIP

■ Save using the SAVE AS command from the File menu and amending your file's name to InProg1, InProg 2, etc. The reason for using SAVE AS with incremental file names rather than SAVE is that the second most annoying thing after losing all your work is to save over work you like after performing a change you regret having made.

LEFT

Digital photographic techniques allow us to explore flights of fantasy as well as achieving more prosaic results. Bizarre images like this can be great fun—so long as the technique is not overused.

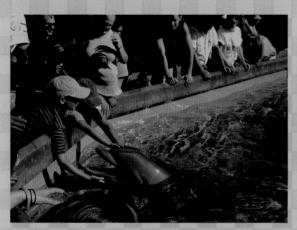
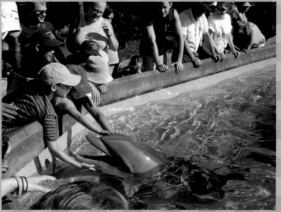

LEFT

We all take photos that are technically lacking. Image-manipulation allows us to correct poor coloration and exposure at a stroke. It is ideal for rescuing shots that might otherwise have been consigned to the trash.

LEFT

Many of us have heirloom photos that have faded with the passage of time. Fading, tearing, and other damage can make photos a shadow of their former selves. A little deft digital wizardry can make these photos better than ever.

SETTING UP PHOTOSHOP AND PHOTOSHOP ELEMENTS

DIGITAL-IMAGING PROGRAMS HAVE A GREAT DEAL OF FLEXIBILITY, BUT TO MAXIMIZE THEIR POTENTIAL, THEY NEED TO BE SET UP OPTIMALLY. THIS SHOULD BE YOUR FIRST ACTION DESPITE THE ALLURE OF ALL THOSE DIGITAL-MANIPULATION TOOLS.

Getting configured

The first thing about setting up your digital-imaging program is to make sure your computer is configured to deal with the huge amounts of data.

It has already been said, but it is important: digital imaging needs plenty of RAM memory and hard disk space. Compromise on either and your application will run painfully slowly. Many professionals—and quite a few enthusiasts—swear by a second hard disk drive for your computer. Not simply because it offers you more storage, but also because it offers your storage somewhere other than the disk that your operating system software and digital-imaging software are located.

Why is this important? Well, digital-imaging programs create a number of (sometimes huge) temporary files. These are stored on a hard disk. If your computer crashes, these temporary files can quickly fill up your hard disk. A nearly full hard disk is only one more crash away from Armageddon: the overwriting or corruption of some of your files, or worse, key parts of programs, or the operating system. Luckily, Photoshop has a flexible way of letting you set it all up to suit you.

Scratch disks and plug-ins

If you have more than one hard disk, you can allocate one other than your system disk (where the operating system software is) to be Photoshop's repository for temporary files. This is much safer and more efficient than doing it all in one place.

Photoshop also has a Preference setting to make the allocation of disks for this purpose. Select Photoshop>Edit>Preferences>Plug-ins and Scratch Disks, and use the pull-down menus to allocated the disks. You'll find that Photoshop warns you if system and Scratch Disks are allocated to the same drive.

To get Photoshop running at its best you need to configure the application for your needs. Do this using the Preferences panels. On the Plug-in and Scratch Disks panel you can direct the application to the Plug-ins folder (which contains all the filters and extensions to the program).

Gamut

Gamut is the range of colors a given output or display medium can display. Some manipulations can create colors that are outside of this range. The gamut warning is a visual warning that colors that cannot be represented in whichever output form that has been selected. Choose a very bright color (yellow or red) to act as your gamut warning. Select Photoshop>Edit>Preferences >Transparency and Gamut for options.

Units

If you are of a certain age, you may find it easier to work in imperial measurements. Younger readers will be more familiar with metric. For digital imaging, though, the key is always pixels. Changing the units to pixels will make it easier to calculate what you need in terms of resolution. Find and select options under Photoshop>Edit>Preferences> Units and Rulers.

The Transparency and Gamut panel of the Preferences panel is useful for choosing background colors and patterns, and choosing a color for gamut warnings: these signal colors that can't be reproduced precisely by the inks in the image.

Photoshop is used in different ways, particularly with regard to scale. Some like to work in Imperial units, or Metric. Others may prefer points and picas. Set these in the Units and Rulers panel.

TOOLS AND TOOL OPTIONS

THE TOOLBAR IS THE MOST IMPORTANT PART OF THE SCREEN. WITHIN PHOTOSHOP, FOR INSTANCE, THERE ARE 26 BOXES, AND 61 TOOL POSSIBILITIES. THESE ARE ALL THE TOOLS YOU WILL NEED TO PERFORM ANY MANIPULATION.

As with virtually everything in Adobe's imaging programs, there is more than one way to access the tools and their options. A small triangle in the bottom right-hand corner of any toolbar square means there are a number of options for that tool. These options can be opposites (Dodge and Burn) or similar items (Rectangular, Elliptical, Single-row, Single-column Marquee tools). Click and hold on the square and the other options will appear.

Alternatively, click once on the box and then just below the menu bar, a box showing all the options for that tool will appear. If it isn't there, select Window>Options.

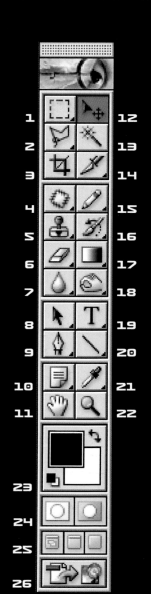

TIP
■ **If at any point you forget which tool is which, just move your mouse so that the pointer is over the square showing the icon for the tool you've forgotten. A small yellow box will appear showing the name of the tool.**

Tool options
Letter in the brackets is the shortcut for the tool.

1 Marquee Selection Tool (M): use to select rectangular or oval shapes, or lines of pixels.

2 Lasso Tool (L): With Conventional, Magnetic, and Polygonal options, use the Lasso to select irregular shaped objects.

3 Crop Tool (C): Use to trim away unwanted elements.

4 Heal/Patch Tools: Applies a texture to an image without altering the underlying color and brightness.

5 Clone Stamp Tool (S): Also called the Rubber Stamp, use the Clone Tool to paint pixels from one area to another to hide distracting elements.

6 Eraser Tool (E): Erases pixels in a layer or through to the background.

7 Blur/Sharpen Tool (R): Blurs or sharpens parts of an image with a brush.

8 Path Selection Tool (A): Selects a path.

9 Pen Tool (P): Draws vector-based outlines that can be converted to selections and/or saved with an image.

10 Notes Tool (N): Use to add annotations.

11 Hand Tool (H): Use to move the image around the window.

12 Move Tool (V): Use to move a selection relative to the original image, or within an image that the selection has been pasted into.

13 Magic Wand Tool (W): Selection Tool that bases the selection on object color.

14 Slice Tool (K): Slices an image into smaller rectangles.

15 Brush/Pencil Tool (B): Selects the Brush Tool for painting.

16 History Brush (Y): Paints an image using data from a History state (an earlier edit of that image).

17 Gradient/Bucket (G): Applies a gradient color (or mask) over an image or, in an alternate mode, fills a selected area with the current foreground color.

18 Sponge/Dodge/Burn Tools (O): Use the sponge for saturating or desaturating an image and the Dodge and Burn Tools to apply traditional darkroom effects.

19 Text Tool (T): Applies text to an image.

20 Vector Shape/Line Tools (U): Applies vector shapes, lines, and lines with arrowheads.

21 Eyedropper (I) Sample the color at a precise point in an image.

22 Zoom Tool (Z) Enlarges the image to see small details, and zooms out to see the result.

23 Foreground/background color selector. Click on the color swatch to choose a new color, then the double-headed arrow to swap foreground and background colors, then on the black-and-white icon to set the colors to black and white.

24 Quick Mask. Click on the right button to convert a selection to a Quick Mask and on the left for Normal mode.

25 Mode Selector. Click on the middle button to set the desktop to black/gray. The right-hand button removes the Menu bar for a clear screen. Return to Normal mode by clicking on the left button.

26 Switch to ImageReady. Click to continue editing your image using ImageReady, and to refine your image for Web use.

MAKING BASIC SELECTIONS

ADJUSTMENTS TO DIGITAL IMAGES CAN BE MADE TO THE WHOLE IMAGE. THE MAJORITY OF DIGITAL IMAGING IS BEST PERFORMED ON SPECIFIC PORTIONS OF THE IMAGE. THIS IS KNOWN TO SOME AS "CHEATING", BUT IT IS CONSIDERED TO BE GOOD PRACTICE BY PROFESSIONAL DIGITAL IMAGERS.

Making specific changes

But how do you go about applying changes to small parts of an image? Well, some tools (the Pen, Pencil, Dodge, Burn, Smudge, Sharpen, and Blur) can be applied just as they are over an area of your choosing.

The rest of the enormous variety of effects at Photoshop's disposal are applied to small areas by means of a selection process. Over the next few pages, we'll start to take a look at the most important skill in the digital darkroom: making an appropriate selection. Incidentally, when you make a selection, the frame of the selected area has moving dotted lines to show its borders. These are rather sweetly known as "marching ants".

The three Marquees

The principle behind the Rectangular Marquee is a simple one. You place your mouse at one corner of the rectangle you want to highlight then click and hold as you drag the crosshairs to the opposite corner of your chosen selection. If you press and hold the Shift key after you've started dragging, your rectangle miraculously leaps into being a square.

With the Elliptical Marquee, the effect is the same, except that you start somewhere above and left of where your oval wants to be then click and

drag downward and right to get an oval. Like the rectangle, if you press and hold the Shift key as you drag, it changes into a circle. The most useful function, though, is if you press and release the Option/Alt key at any stage. This centers the circle or oval where you first clicked. The two line-pixel selection methods in Photoshop let you select a single row or a single column of pixels.

Magic Wand

The Magic wand—at least the first time you use it— appears to live up to its name. It selects all pixels of the same color value as the pixel you click on. If you only want to select those of the same value, immediately touching the pixel you've clicked on, you can check a little box in the Magic Wand Options bar marked Contiguous.

Also in the Magic Wand Options bar, you'll see Anti-alias and Tolerance. Leave the first box checked, as it will give you smoother selections, unless you have an absolutely crisp edge to the area you want to select. The tolerance box contains a number between 0 and 100. At 0 it means only exactly the same value of pixel will be selected, the higher the number, the more tones the Magic Wand picks up.

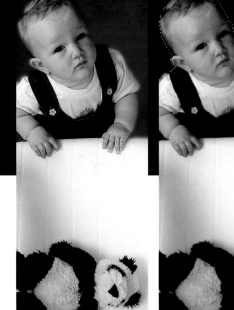

Lasso

As its name implies, this tool "ropes" in detail.
It comes in three forms: Freehand, Polygonal, and
Magnetic. The Freehand Lasso enables you to draw,
freehand, around the area you want to select. If you
are skilled, and have a large, detailed monitor, this
is best. The Polygonal Lasso lets you click on points
around the area, describing an object as a multi-sided
shape. It is slower and less smooth than the Freehand
Lasso, but as you click each point in, you can correct
by going back with the delete key. The last is the
cleverest: the Magnetic Lasso automatically finds
the edges of an area (by means of comparing pixel
values) and leaves click points as it sticks to the
edges. Like the Magic Wand, you can alter its
tolerance from very little, where you have areas
similar in tone, to a lot where you have clearly
defined edges already.

ABOVE LEFT
*The Lasso is ideal for this image. The color changes
and irregular edge make this the best option.*

ABOVE RIGHT
*Select the Magnetic Lasso and drag the cursor around
the edge of the child. It will magically attach itself to
the boundary. If the contrast between the child and
background is low, you may need to click occasionally
to "lock" the selection line to the edge and prevent it
jumping to another position.*

RIGHT
*Close inspection shows that the selected area is good,
if not 100% precise. Where the difference in contrast
and brightness is low, precision is lowest. We can fine-
tune selections like this using other tools, the Quick
Mask, for example.*

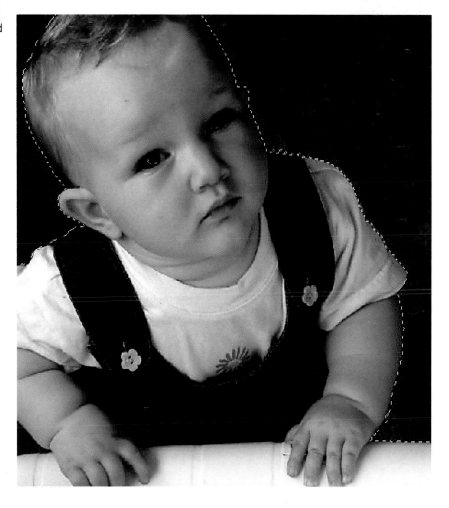

COMPLEX SELECTIONS

SO FAR WE'VE LOOKED AT THE BASICS OF MAKING SELECTIONS BUT, IN THE REAL WORLD, NOT EVERYTHING IS AS IDEALIZED AS THESE EXAMPLES. FORTUNATELY, PHOTOSHOP PROVIDES ADDITIONAL TOOLS TO AID THE MAKING OF PRECISE SELECTIONS.

Adding and subtracting from selections

Sometimes you want to use the Marquee tool for speed even though your chosen selection subject is not a regular shape. Luckily, is it pretty simple to modify selections. After making your initial selection you can add to it by using the same (or indeed a different) selection tool by holding the Option/Alt key down to remove from a selection or Shift key to add to it. You don't need to hold them down after you have clicked initially on the second selection. Or click on the button in the Options bar corresponding to Add to selection or Subtract from your selection.

Color range

It might not always be shapes in close proximity, but items of a similar color that you want. You could use the Magic Wand, but that relates to levels rather than just color. Choosing Select>Color Range allows you (again, with a changeable degree of selection in the Option bar) to pick all subjects in the image with a certain color. Unless you are very lucky you'll find that your chosen color isn't continuous, and there may be small gaps in the selection. Within the Color Range dialog box, you can add to colors by clicking on the eyedropper with a "+" sign next to it, to add as many additional colors as you want. Watch out for other areas that you don't want to be selected, though. These can be removed with selection tools with the Option/Alt key pressed, or the Remove-from-selection button pressed.

Modifying

Another method of adding or subtracting from an image is to choose Select>Modify. This section of the Select menu offers four possibilities: Expand, Contract, Smooth, and Border. Expand increases the size of the selected area by a number of pixels that you specify; Contract, logically, does the opposite; Smooth makes the selected areas boundary less bumpy or cornered; and Border, enables you to select a border (inside and outside the initial selection).

Inverting

Sometimes it is easier to select those areas that you don't want than those you do. This is where the Select>Inverse function comes in. It basically swaps over what is selected for what isn't.

Feathering

Finally: the most powerful tool of all: Feathering. This feature is available in most selection tools in the Options bar. It allows pixels to be partly selected or, rather, it will only partially apply any manipulation you perform on the boundary of the selected area as specified by you. Feathering makes the effect most pronounced in the center of a selected area, and peters out as you get to the edge. This is sometimes the quick-fix to use when you find it impossible to do a clean cut-out: for example, trying to select the hair of a fair-haired person against a light background.

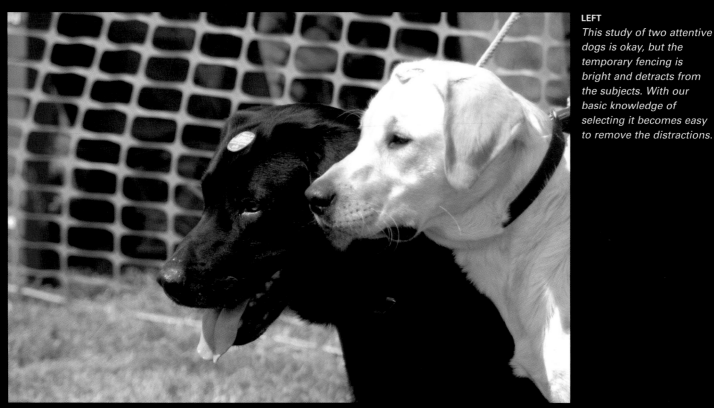

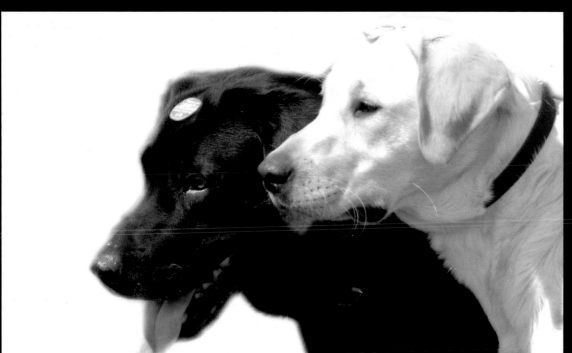

03

SIMPLE MANIPULATIONS

We've looked at the essential tools. But now it's time to stop looking at the theory and start looking at the practice. Whether you want to make some image repair or simple manipulation, the first steps in digital imaging are about putting things right.

We'll learn how to rescue poor photographs. Dull, underexposed shots can be brought back to life—and no-one need ever know that you got the exposure wrong. You can turn ordinary landscapes and portraits into something special, restoring all the original color and vibrancy.

In terms of composition, few images are perfect when you take them. There may be unfortunately timed passers-by, or undesirable elements over which you have no control: parked cars, or street signs, for example. But as you become adept at

using the Clone tool you'll discover how to move or remove any unwanted elements. Bending the truth? Possibly. Delivering a better photo? Absolutely.

You can even take control of the weather. Not every day is, in photographic terms, perfect, but you can improve on nature and replace featureless, overcast skies with something more photogenic.

And this chapter is about "simple" manipulations because all the effects you'll see here really are simple to create—even if the results are anything but simple.

CORRECTING FOR UNDEREXPOSURE

UNDEREXPOSURE IS ONE OF THE MOST COMMON PROBLEMS WITH SCANNED AND DIGITALLY CAPTURED IMAGES. FORTUNATELY, THERE ARE SEVERAL, EASY WAYS TO FIX IT.

Choosing the right tools

In Photoshop, there are a range of alternatives for making corrections: Variations, Levels, Curves—and more under the Image>Adjustments menu.

So, how do you choose which is best, when you've got dark everything?

In Variations, you can compare the effects of the different types of adjustment, but you want to do things the easiest way possible at first.

Image>Adjustments>Auto Levels will examine the image data and make a judgement about how the image should be altered. With images that are very nearly right and don't contain single, strong colors, Autolevels can work, and is quick. The main problem is that Auto can be wrong in terms of the

levels it chooses, and it can change the color balance of an image. A good alternative is Auto Contrast. This alters the levels but not the color balance. Again it is good for quick, easy repairs, but it can overdo things.

Brightness/Contrast is a manual version of Auto Contrast. It lets you adjust the brightness and/or contrast of a whole image, and monitor the effects as you do them.

The original image: flat and underexposed.

Fill-in flash command: too dark.

Backlighting command: too washed out.

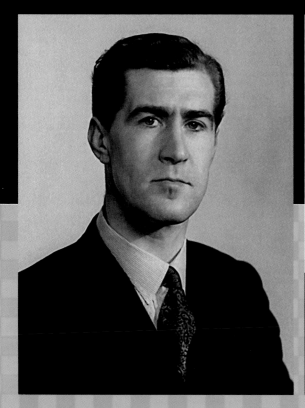

ABOVE LEFT AND RIGHT
In old photographs it can be hard to determine whether an image is underexposed or lacking in contrast. Fortunately, Photoshop gives us Brightness/Contrast. By boosting the contrast (10 percent in this case), and the same for brightness, we get a more acceptable result.

Quick Fix command: Auto Contrast. *Quick Fix command: Auto Brightness.*

TIP
■ **Try to perform whichever exposure adjustment you are going to do only once. Repeated changes in the data will cause loss of detail. With digital imaging, once it is gone, it's gone. The only exception to this rule is when you are performing exposure changes on different parts of the image.**

USING LEVELS

SOME OF THE AUTO TOOLS PROVIDED IN PHOTOSHOP DO A GREAT JOB, BUT SOME ARE LESS EFFECTIVE, AND YOU'LL REALIZE THAT ESCHEWING THE AUTO TOOLS IN FAVOR OF THE "LONGHAND" METHODS PAYS DIVIDENDS.

BELOW

The original histogram, top, shows there to be areas to the left and right of the graph with little information. This means that there are no true blacks and whites in the image. By moving the sliders inward, as shown in the histogram, bottom, the tonal range is increased so that the darkest parts of the image are deep black and bright white.

TUTORIAL
Using Levels to correct underexposure

This seascape is underexposed. The sky was bright, and it fooled the meter. Unfortunately, applying Auto Levels just gave an altogether wrong set of levels.

1 Select Image> Adjustments>Levels to show a histogram. A histogram is the graphical representation of the main balance of tones in an image. If the graph is heavy on the right-hand side, you have lots of light tones, and if it's heavy on the left you have too many dark tones. But these biases don't mean that there is a problem with the image levels. With a histogram, you are looking for the gaps at the bottom rather than the height of the peaks to identify a problem. Here, there is a large gap on the bottom left, but no gap at the right. So, our highlight tones are fine, but there are too many shadow tones where the midtones should be.

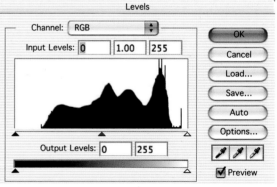

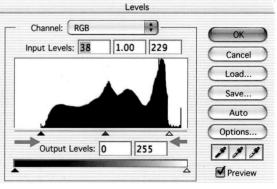

Preview

TIPS

■ If you've applied a changed set of levels and don't like the result, select Edit>Undo rather than trying to amend. You can get a better result by trying a different application rather than correcting a correction. You'll also retain more detail.

■ As an exercise, compare the effects using Auto Levels with what you have executed manually.

2 In order to correct this, we will need to move two of the three sliders. The far left-hand slider is where you want your black point to be. Slide it to the right until it reaches the first part of the graph where there is some detail, to set the black point. Check the Preview box, and your image will look darker, not lighter.

3 Next, take the middle slider and slide it left until you have the balance of shadows, midtones, and highlights that you want. You have just set the midtone point.

4 Click OK, and you have corrected the exposure of the image.

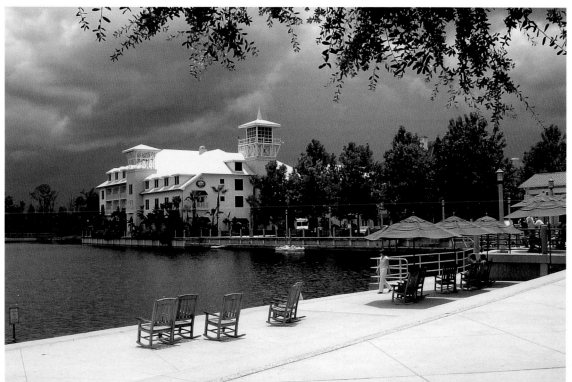

LEFT
After correcting the levels by adjusting the sliders on the histogram, the result is a much more "punchy" image. The tonal range is more balanced. The lighter parts of the image are brighter and the darker are less "muddy."

USING CURVES

USING LEVELS IN PHOTOSHOP CAN BE REMARKABLY EFFECTIVE BUT IT IS A ONE-DIMENSIONAL ADJUSTMENT: WE CAN MOVE SLIDERS ONLY BACK AND FORTH.

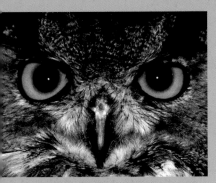

Our original wildlife image before we apply Curves.

TUTORIAL
Exploring the functionality of Curves

Curves is great for correcting all kinds of image problems, some of which we explore here. In an ideal image the curve (which is, rather misleadingly, a straight line) runs straight from black to white. A straight line, running from bottom left to top right, indicates normal exposure and contrast—at least in the sense of the original exposure and contrast.

To increase contrast, make the line steeper: to decrease contrast, make it shallower. To increase the lightness of the shadows, pick up the bottom left-hand pointer with the cross tool in the Curves box (as opposed to the Pencil tool) and lift the bottom left corner up the left-hand side of the square. To reduce the brightness of highlights, move the top right-hand dot down the right-hand side. For most purposes, though, the real benefit of Curves is being able to move midpoints around, to the left or right and up or down. To make a new midpoint, click anywhere on the line and drag it up to make it lighter and down to make it darker.

1 Select Image>Adjustments>Curves. With the Curves setting you can also apply pegs to stop other parts of the curve from being affected by the change. Simply click a little bit either side of the point you want to move and then click on the central point. When you drag it up or down, only the part of the curve between the two pegs will move. This gives you pretty tight control over the midtones and even portions of the midtone area.

2 Thus far, you have used the RGB (or Master) channel for Levels and Curves. If your image has a slight color bias, or one becomes evident after a global Levels or Curves change, you can correct it by selecting an individual channel (i.e. Red, Green, or Blue) in the Channel drop-down menu. This (along with the ability to peg curves at any point from shadow to highlight) gives you extremely fine control over the appearance of an image.

3 If you want to make a very quick manual change in either Levels or Curves, then all you need to do is find parts of the image that you want to come out as black and white. Click on the left-hand of the three eyedroppers in the Curves or Levels dialog, then click on the part of the image you want to be black. Next, click on the right-hand eyedropper and find a part of the image you want to be white, and click on it. Don't try too hard to find a midtone gray with the eyedropper—gray is a lot rarer in nature than white or black. Just use the black and white points to get the image 90% there, then tweak the Curve (or the midtone gray slider in Levels) to sort out the midtones.

Curves

Channel: RGB

Input: 104
Output: 118

OK
Cancel
Load...
Save...
Smooth...
Auto
Options...

☑ Preview

LEFT
A screengrab showing what the Curves "line" looks like. Move the points on the line to create different effects.

BELOW
Even with wildlife portraits, the eyes are the most important part. This pair of images shows how to adjust the lights in the eyes in a portrait with a few simple clicks.

TIP
■ For portraits, using white and black points is easy. If you can see an eye, you can find the pupil and the white of the eye. Two clicks, and your image is corrected. This works well if the eye is in full light, but can erase highlights if the white of the eye is in shade.

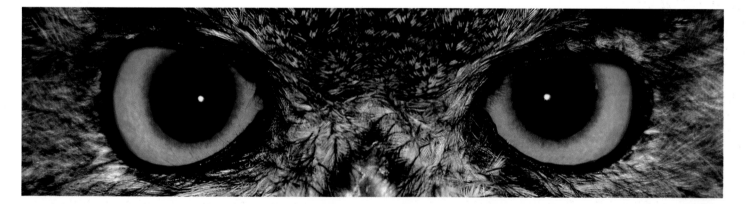

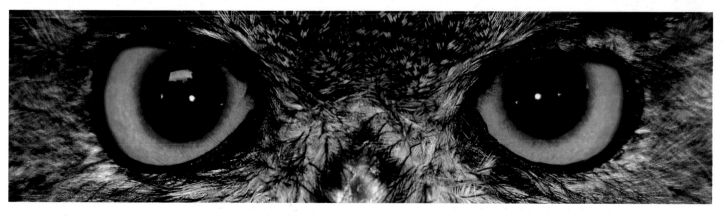

CLONING AND HEALING

WITH THE SEEMINGLY MAGIC CLONE OR STAMP TOOL YOU CAN REMOVE UNWANTED ELEMENTS
FROM A SCENE, MOVE THEM AROUND, OR ADD A WHOLE NEW COMPONENT
TO AN IMAGE.

Behind the digital trickery the Clone feature has an obvious function. It does not move a part of an image, and neither does it render a part of an image transparent to reveal the background behind it. Its specialty is to add or remove unwanted elements by "painting" one part of an image over another.

There are any number of tricks you can achieve with the Clone tool: adding an extra pair of eyes, or indeed a whole other head in a portrait. But, once you've had some fun with it, it is worth exercising a bit of caution. Sometimes, when there is a lot to copy over, rather than use the Clone tool, it is often better to use Layers, and simply use the Clone tool to touch up.

With the full version of Photoshop, you get the Healing brush. More complex than the Clone tool, it is effective in areas where you want to keep the lighting effect of the patch being cloned onto. When you paint with the Healing tool, initially—until you release the mouse button—it looks exactly the same as when you are cloning. When you release the clicker, the symbol that tells you that Photoshop is "thinking" appears. In normal mode, when it disappears, your cloned section will have taken on the light, shade, and some of the color value of the area you've cloned over. If you switch to Replace mode (in Options, below the main menu) the effect is identical to cloning.

For larger areas, you can use the second setting of the Healing Brush: the Patch tool. With this you draw (free hand) around either the area you are cloning from, or, for complex target areas, you can specify only the shape you are drawing around for healing. Clever stuff, but unless you are pasting similar tones onto one another, the Healing Brush is more restrictive than the Clone tool.

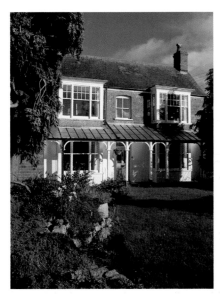 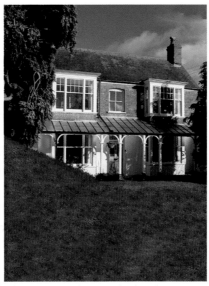

A realtor took a picture of a house before the vendor grassed over the flower border. Conscious that buyers might feel misled, she used the Clone tool to update the picture. First, she used a soft-edged brush with a 47-pixel-diameter. The appearance was obviously cloned (see far left), so she tried again with a hard-bristled, 100-pixel-diameter brush. This gave a nice, random look (see left).

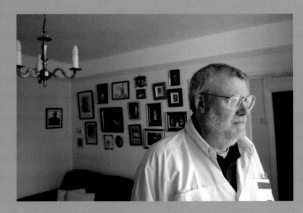

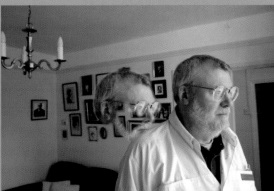

FAR LEFT
*The original image of
a man on his own in
a room.*

LEFT
*Using the Clone tool
and a hard-bristled brush
to work in a "twin".*

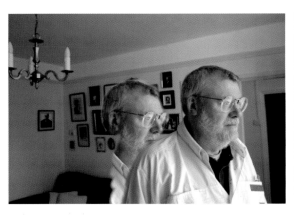

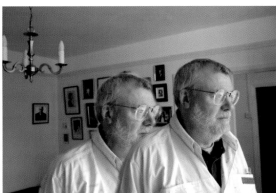

FAR LEFT
*More of the "twin"
appears, peering over the
original subject's shoulder.*

LEFT
*The final image, with
both versions of the
subject in place.*

TUTORIAL
Using the Clone tool

The Clone tool can be used to provide this man with
an identical twin.

1 We'll use the tool to clone pixels of the man
himself and paint them to a position just behind
him. Begin by selecting the Clone tool and a soft
edged brush.

2 Press Control and click with the mouse on a point
in the center of the man's head to define the
"clone from" point. Reposition the mouse where
you want the pixels at this point to be painted.
With a soft-edged brush selected, begin painting
the new image over the old.

3 As you proceed, take care that you don't paint any
of the background adjacent to the man to the new
position. Take care too that you don't overpaint the
subject with the copy of himself. It's important
that the subject appears to be behind the original.

4 Continue to fill in the subject until you have
completed the cloning. If you've done the job
well, anyone who takes a look at the image will
need to do a double take!

TIP

■ **You can change the brush properties used on the Clone tool
in the Brush Options bar. Both the hardness of the tool and its
size (in pixels) can be changed, and as you don't have to clone
a subject in one go, you can choose a big brush size for the
main part and a small, hard-edged brush for edge detail.**

REMOVING UNWANTED ELEMENTS I

IT'S A VERY LUCKY PHOTOGRAPHER WHO FINDS A SCENE COMPOSITIONALLY PERFECT. SO MUCH CAN CONSPIRE AGAINST US: THE WEATHER, PEOPLE, AND SIGNAGE. IMPORTING EXISTING PHOTOS CAN INTRODUCE OTHER DEFECTS, SUCH AS DUST AND SCRATCHES, THAT CAN BE RUINOUS.

Dust and Scratches filters

There's no doubt that dust and scratch marks are a serious problem when scanning and are, to some degree, unavoidable. With this in mind, many scanner manufacturers have included special software modules in their scanner-driving software that identify and remove many dust and scratch blemishes as you scan. This can be remarkably effective and has only a minor effect on the quality of the image.

Alternatively, Photoshop includes a filter called Dust and Scratches, which works by blending areas of the image together to obliterate fine detail, but which can also result in a softened image. It's best to use this filter with care. Select an area first, such as the sky, and apply the filter only to this. In more busy areas—in image terms—stick with the Clone tool.

TUTORIAL
Removing random blemishes

Dust and scratches includes any random blemishes that affect images whether they are obvious marks on the original images or are due to poor presentation or printing of those images. The optical surface of a scanner can produce similar damage too.

The original image with dust marks and distracting tramlines.

Using the Clone Stamp tool to deal with small, but obvious dust and scratch marks.

Using the Clone Stamp tool to carefully remove the tramline scratches from the image.

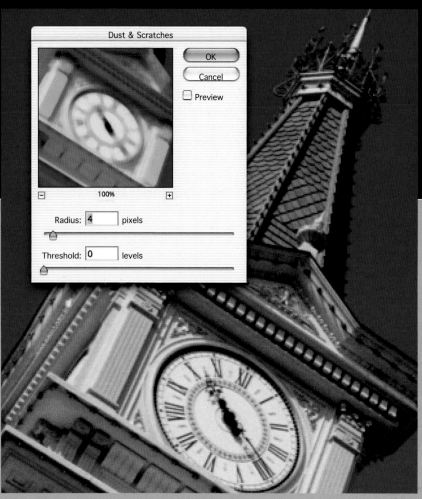

The Dust & Scratches dialog box showing a preview of a clock tower, with settings:
- Radius: 4 pixels
- Threshold: 0 levels

1 Begin with the tramline scratches. Select the Clone Stamp tool (Rubber Stamp) from the toolbox, and use the pull-down menu on the Tool Options bar to select a narrow, soft-edged brush. Press the Option/Alt key and click on a point adjacent to the scratch to select a "clone from" point, and then click on the tramline to paint over it. Keep checking your work for authenticity, particularly in areas such as the sky where there are subtle variations in color. Selecting a "clone from" point too far from the tramline can produce very obvious results. Use the same technique to attend to all the discrete dust marks over the image.

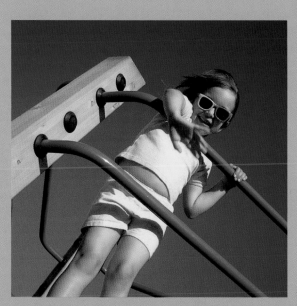

Our final image is clear and sharp, and makes the memory a pleasure to relive.

2 Where the tramlines cross well-defined areas (such as this wood climbing frame) you'll need to select a "clone from" point that is parallel to the scratch to copy and conceal it well.

3 After a little delicate work we have a good, clean image. Yes, it is fiddly and time-consuming. But rest assured, next time you scan an image you'll pay more attention to cleanliness.

ABOVE
The Dust and Scratches filter is often selected as a quick fix for a dirty or scratched image but it does have drawbacks. It achieves the reduction or removal of marks by blurring adjacent pixels over the blemish. This "softens" an image which, to cover large marks, will result in unacceptable blurring of the image.

REMOVING UNWANTED ELEMENTS II

ONCE YOU HAVE A CLEAN IMAGE, IT'S TIME TO TAKE A CRITICAL LOOK AT YOUR COMPOSITIONAL ELEMENTS. SO OFTEN A SCENE IS SPOILT BECAUSE OF ARTEFACTS THAT, OFTEN, WE DON'T NOTICE UNTIL OUR IMAGES ARE PRINTED OR DISPLAYED ON A COMPUTER SCREEN.

LEFT
The original shot of the Railroad Crossing sign.

MIDDLE
Even sizeable obstructions can be removed entirely with deft use of the Clone tool.

RIGHT
Going, Going, Gone!

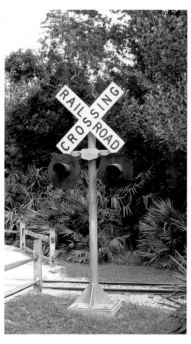 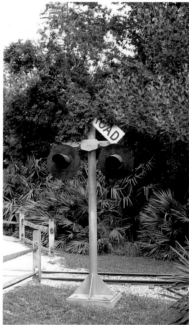

TUTORIAL
Making elements disappear

We can now use the Clone tool to remove or modify elements using a combination of the techniques we've used over the last few pages.

1 Even sizable obstructions such as this railroad crossing sign can be easily removed using the Clone tool. The removal process involves painting over the signage using elements from the background. Fortunately here there is sufficient background to achieve this easily. If we were not so lucky we could use a second image to provide the relevant material.

2 Begin by selecting a swatch of foliage and paint over the Railroad Crossing sign. Keep changing the "clone from" point so that the pattern does not duplicate the background too closely. A soft-edged brush is best so that the the new pixels blend in seamlessly. As we progress down the sign to the post and base make sure you select the appropriate background.

3 Finally, clone a section of the railroad and railbed to obscure the final part of the sign. Ensure you get the alignment right here as errors in geometrically precise areas like this are obvious. The result is a perfect removal job.

CLONE TOOL DO'S AND DON'TS

• Don't clone from a point too close to the "clone to" point. Unless you're correcting minor blemishes, try to select an appropriate point as far as possible from that area being corrected. If you do clone from too close by you risk repeating a pattern of cloned pixels that looks very obvious.

• As a rule, don't reduce the intensity or opacity of the Clone tool. A semi-transparent clone looks rather absurd and very obvious.

• In areas of constant or gently changing tone (such as the sky), use a soft-edged brush. This avoids any abrupt edges. Conversely, in areas with fine detail, a hard-edged brush is better.

• Set the Clone tool's Cursor to Precise in the Preferences dialog (Photoshop>Edit>Preferences>Display and Cursors). This will ensure that you can be absolutely precise in determining "clone from" and "clone to" points—essential if you need to align details. Set the cursor to Brush Size if you want to be sure of the extent of the cloning.

• If there is still some residual element of cloning in your finished image, apply the Add Noise filter (Filter>Noise>Add Noise) at a very modest setting to obscure any remaining artefacts.

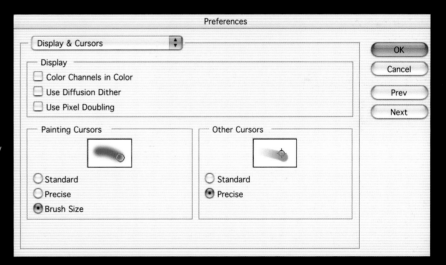

TOP
"Zebra striping" occurs when you clone from a point too close to the "close to" point.

ABOVE
In Preferences, set the Cursor preference to Precise for exact cloning.

INTRODUCTION TO MASKS

PHOTOSHOP'S MASKS HAVE BEEN BORROWED FROM THE PRINTING WORLD. WHEN PRINTERS WANTED TO PROTECT A PART OF AN IMAGE FROM AN EFFECT OR A TECHNIQUE ON A PRINTING PLATE THEY WOULD USE A PAINT-ON RUBBER COMPOUND, OR "MASK".

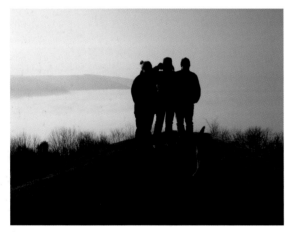

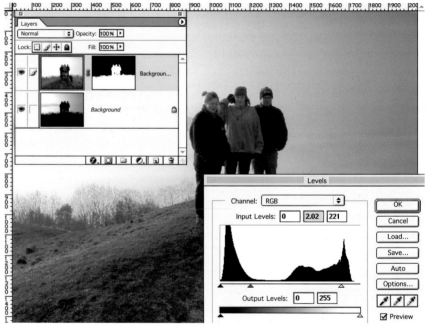

ABOVE
The original image. Strong backlighting has rendered this group portrait as a silhouette. As it stands, there is little detail.

RIGHT
Creating a Layer Mask lets us determine which part of the image to modify. Here, the mask has been applied to the sky/background.

TUTORIAL
Using Masks on underexposure

1 We begin by making a selection. Use the Magic Wand with a tolerance of about 20, clicking on the sky (with the Shift depressed after the first click to add to your selection) until all the similar light tones have been picked up. You'll probably find that there are lots of tiny circles of unselected areas. These are areas of anomalous tone that the Magic Wand cannot annexe. Choose Select>Modify>Expand and enter 1 or 2 in the Pixels box. This should address the problem.

2 Now choose Layer>New Layer>Background. Click OK, then click OK once more in the box that appears (if the Layer window isn't already showing, choose Layers from the Window menu).

3 You should now see a layer called Layer 0. Go back to the Layer menu and select Duplicate Layer. Click OK. You've now copied your original image onto a second layer. Marching ants should still be showing on your selection, and you can now change these into a layer mask by selecting Layer>Add Layer Mask>Hide Selection.

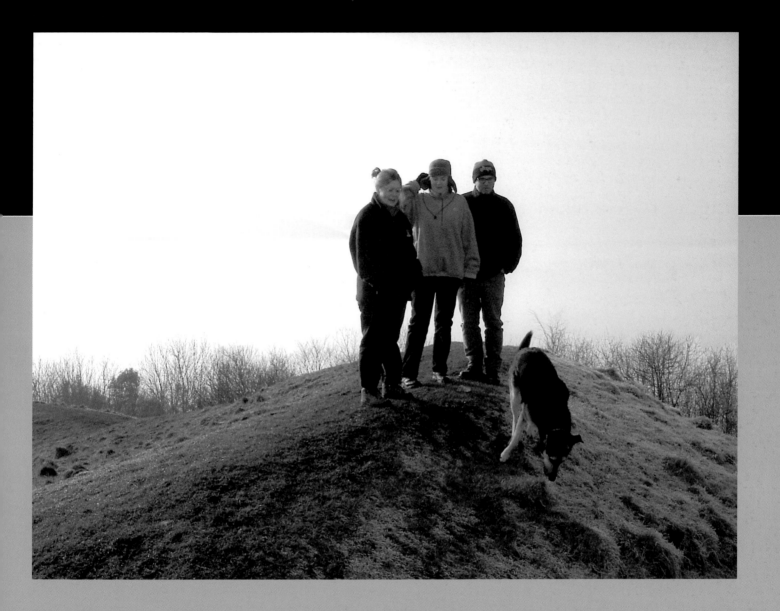

The top layer is now showing just the bottom half of the image. Click on the left-hand thumbnail of the top layer to highlight it.

4 Select Image>Adjustments>Levels to adjust the levels of the foreground subject. The effect of the masking is to reduce the density of the foreground subjects, enabling you to see them as intended.

TIP
■ **If you get a small halo around a mask, add a second mask with the same selection but feathered by a couple of pixels (Select>Feather). Combine the two masks, and the halo should disappear.**

ABOVE
After masking and adjusting the Levels, we have a successful, balanced image.

EXPANDING AND SMOOTHING WITH THE FEATHER TOOL

LIKE AN EXPENSIVE HAIRPIECE, THE MARK OF GOOD IMAGE-MANIPULATION IS THAT YOU CAN'T SEE THE JOIN.

Because of the way digital devices use discrete pixels, digital images are visually composed of square blocks. This can give curved objects a "stepped" appearance which needs to be smoothed. With features like hair or twigs, you simply can't get cleanly around them unless you draw around every pixel. Even if these fine-detail items occupy only two percent of a 3-megapixel image, it would still involve over 60,000 click points with the Lasso tool. The cleanest, and quickest, method is to blend in selections with their backgrounds. We achieve this blending by a process we describe as "feathering".

You can apply a feathering amount to a selection in one of two ways. To pre-set, select the Feather box in the Options dialog found in your selection tools. To feather after you've made your selection, choose Select>Feather.

What the Feather function does is spread the edge of a selection over a number of pixels. This means that any effect you apply to your selection (Levels, or a filter effect) will only be partially applied to that pixel.

TIP

■ **When using Clouds, choose colors that are easy on the eye. Click in turn on each of the foreground and background color boxes in the toolbar, and select a color from the dialog box. Alternatively, use the Eyedropper to match the color of any pixel in your image.**

TUTORIAL
Feathering out a bad background

1 This portrait is not bad, but the background color is unflattering and the chair is a little intrusive. To produce a better shot we should substitute the chair with a new background.

2 Rather than selecting the subject using the Lasso tool, it is preferable to use the Magic Wand to select the background and chair.

3 However, when we examine the boundary closer a few errant pixels, creating a jagged edge, are visible, which is neither natural nor desirable. By choosing Select>Modify>Expand and setting Expand at 3 pixels (this varies according to image size and resolution), we produce a softer edge.

4 Unfortunately, this effect also produces an odd gray halo around the selection edge. To remove, choose Select>Feather (again, at 3 pixels) and hit the Delete key two or three times. Each deletion removes a few halo pixels.

5 Our subject is cleanly isolated against a plain white background. He is now ready for a new one. Choose Select>Modify>Contract and insert a value of 3 pixels, then select Feather with a value of 3 pixels. This will soften the edge of the selection we are about to fill. Select Filter>Render> Clouds. With appropriate foreground and background colors (it's entirely your choice), we get a much more effective background.

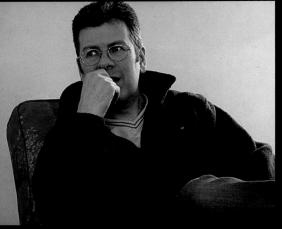

The original, rather unflattering portrait.

Using the Magic Wand to select the plain chair and background, and isolate the subject.

On close inspection, there are a few escapee pixels...

...so Modify>Expand produces a softer edge. To erase the gray halo this creates, use the Feather tool.

Our subject is isolated against a white background, ready for a nice, new one.

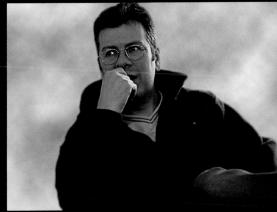

The Clouds filter, and an appropriate selection of colors, makes for a much more dynamic image.

QUICKMASK IN PHOTOSHOP

HERE'S A POTENT PHOTOSHOP FEATURE WHICH YOU'LL FIND MORE AND MORE USEFUL AS YOU GAIN PROFICIENCY. HERE, YOU WILL USE IT TO MOVE A SUBJECT TO IMPROVE COMPOSITION.

As your skill at moving selections improves, you'll find yourself using the QuickMask feature more and more. The beauty of QuickMask is that while it is possible to input different degrees of feathering when using the selection tools, it isn't always straightforward. With QuickMask you make the selection (or rather define the area not to be selected) by using any of the painting tools. This means that where you want a sharp-edged selection you can use a hard-edged brush, and where you want a blended selection, you can use a soft-edged brush. And you can use both on the same image in the same selection process.

QuickMask really comes into its own with the Gradient painting tool (see page 62), and it is also a very handy way of making minor adjustments to selections you've already made, using either the painting tools or the Eraser tool. All you need to do is click on QuickMask, and the parts of the image not selected are shown as a solid color. The default color is red, but you can alter that if it clashes with the colors in your image.

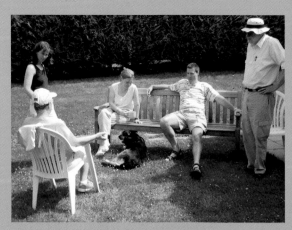

The original image, with the dog in a slightly awkward position.

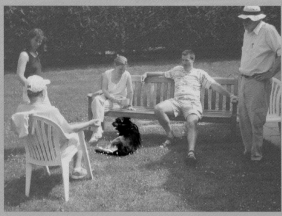

Selecting all other areas around the dog with the QuickMask button.

TUTORIAL
Using QuickMask to move elements

1 This scene would look more balanced if the dog was in the empty part of the image in the center foreground. Moving the dog is an ideal opportunity to use the QuickMask feature. Begin by selecting the dog using the Magic Wand or Lasso tools.

2 It's unlikely that you'll make a perfect selection first time. To refine the selection, click on the QuickMask button on the Toolbar. The area outside the original selection is now masked and appears red. If we zoom in to the dog we can use the Paintbrush tool to modify our selection. Painting with black adds to the mask and with white removes the mask. Use progressively finer brush tips for precise refinement.

3 Once you are happy with the selection, click on Normal mode. The selection will return with the refined edge thanks to QuickMask. Select the Move tool and move the dog to the new position. You'll need to work deftly with the Clone tool to replace the "hole" left by the dog.

4 Look closely at the final image. Ensure that the blend of the dog into its new slot, and the cloning, is convincing. You may need to use the Burn tool to add shadows around the dog, following other shadows in the image.

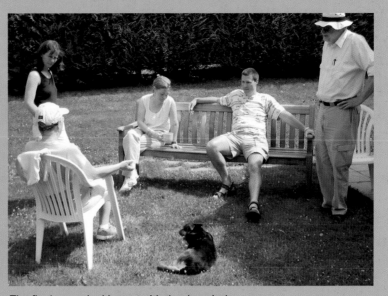

The Move tool enables us to reposition the dog, leaving a hole which can be filled with the Clone tool.

The final, reworked image with the dog nicely positioned in the foreground.

GRADIENT TOOLS IN QUICKMASK

QUICKMASK IS A VERY USEFUL WAY OF MAKING LARGE SELECTIONS BY EXCLUDING, OR MASKING, AREAS OF AN IMAGE. YOU CAN USE THE BRUSH TOOLS TO REFINE THE SHAPE OF THE MASKED AREA, AND, MOST SIGNIFICANTLY, YOU CAN MAKE GRADUATED SELECTIONS.

TUTORIAL
Using QuickMask to balance elements

1 Digital cameras are often unable to achieve good contrast between the sky and foreground. If you try to balance the image with Levels, you get either the foreground or background right, but not both.

2 To get around this, combine the QuickMask with the Gradient tool. Apply a gradient across the frame, from top to bottom, to vary the amount of influence the Level command will have on the scene. Display the selection by hitting the Q key.

3 Apply Levels (Image>Adjustments>Levels), and dragging the left-hand slider right, you darken the sky and reduce the effect of atmospheric haze.

4 Choose Select>Inverse to switch the graduated selection, and lighten the foreground with Levels, dragging the right-hand slider to the left to add shadow detail and lighten the foreground.

Poor contrast and lighting levels are common in digital photos.

The mask has been positioned to include most of the foreground.

Haze can be reduced by moving the sliders to the right.

A dramatic improvement to the balance of the image.

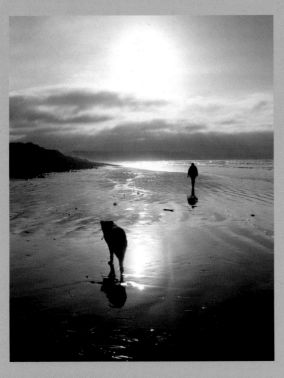

FAR LEFT
Original image, lacking critical sharpness at the subject.

LEFT
Applying the Mask gradient over the foreground.

TUTORIAL
Using QuickMask for total sharpness

1 Use QuickMask and the Gradient tool combined to adjust an image where you may have focused inadvertently a little closer than you would wish, and not picked it up on the camera's LCD screen.

2 Select Filter>Sharpen>Unsharp Mask to add more sharpness in the far distance where it is needed and less in the foreground where it is already sharp. This enables you to produce a landscape with infinite sharpness.

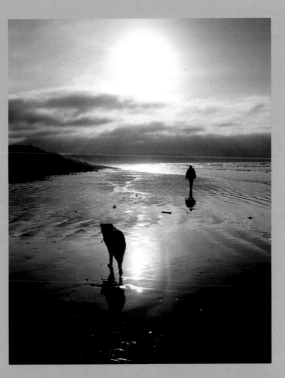

FAR LEFT
The effects of the Mask are evident.

LEFT
The final sharpened image, with the subject in sharper focus.

SAVING SELECTIONS

IF YOU'VE SPENT TEN MINUTES GETTING A COMPLEX SELECTION EXACTLY RIGHT YOU MIGHT, INADVERTENTLY, LOSE EVERYTHING. REMEMBER TO USE THE SAVE SELECTION COMMAND TO AVOID THIS. IT IS ONE OF THE GREATEST TIME-SAVING FUNCTIONS IN THE PROGRAM.

There are certain factors to bear in mind when saving a selection. Firstly, you should not crop the image after you've saved a selection, unless it is the final thing you are going to do with the image. Secondly, when naming your saved selections, make sure that you note any feathering or size changes made to it compared with another saved selection. There is no reason not to save a simple selection and then a feathered selection, just as long as you know which is which when you come to reload them.

You can select different parts of the image (maybe the main subject and background with overlapping feathered selections, see page 58) and know that they will blend perfectly. You might also have a series of subjects, each of which requires different treatments or an effect, like the Blurring filter.

The key thing about the saving of a selection is that you are under no obligation to use it, but it is there if you need it. In my experience, the first time you need it is the first time you've forgotten to save it. As a rule of thumb, any selection process that takes more than ten seconds to complete should be saved.

Making a complex selection can be problematic. And it is all too easy to find that by an errant click of the mouse you have lost much of your work. Always save your selection as you proceed. The benefit is that you can return later and load previously saved selections for any new modifications.

TUTORIAL
Saving selections

1 To isolate this man feeding a walrus means using different selection tools. It will take time, but is not difficult. However it would be easy to mis-select, which could lose a lot of work.

2 Use the Magnetic Lasso to select the Walrus. You may need to manually describe the whiskers around the face by adding to the selection using the standard Lasso.

3 Save by choosing Select>Save Selection. Type in a name for the selection in the dialog box.

4 If we now display the Channels dialog (Window> Channels) you will see that a new channel, an Alpha Channel, has been created corresponding to the selection.

5 Extend the selection by adding the man. When we save this new selection, you get a second Alpha Channel.

6 Add the foreground furniture to the selection using the Polygonal Lasso. We have a third Alpha Channel. These will be saved with the image.

7 When you subsequently return to work on the image you can recall any of these by choosing Select>Load Selection and selecting the required Alpha Channel from the pull-down menu.

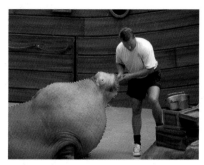

Using the Magnetic Lasso to select the Walrus.

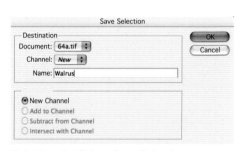

Selecting the Select>Save Selection dialog box.

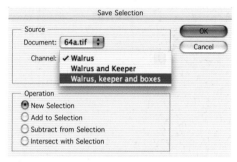

A new channel for the Walrus and the Keeper.

Extending the selection by adding the man adds another Alpha Channel.

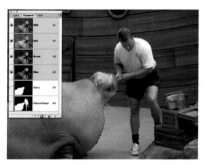

Adding the foreground furniture to the selection using the Polygonal Lasso.

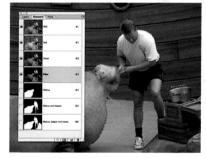

You can return to work on the image by recalling any of these channels.

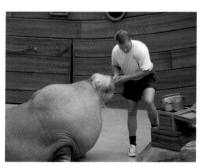

Our final image, with the new element incorporated into the scene.

PHOTOSHOP'S HISTORY BRUSH

It is not strictly true to say that you can't step back and still keep work you've done. Photoshop has a feature called the History brush. If you open the History palette, you can step back in the imaging process. Just like any of the other brush functions (Clone, Dodge, Burn, etc) your History brush can be hard-edged or soft-edged. You can also choose as large or as small a brush as you want.

ADDING A NEW SKY

HERE'S ONE OF THOSE TECHNIQUES THAT IS INCREDIBLY SIMPLE YET PRODUCES IMPRESSIVE RESULTS. FEATURELESS SKIES—WHETHER HAZY, PALE BLUE OR OVERCAST—CAN WEAKEN AN OTHERWISE GOOD PHOTOGRAPH. THIS IS EASILY IMPROVED BY IMPORTING A BETTER SKY FROM ANOTHER PICTURE.

TUTORIAL
Creating a simple sky

1 Begin by selecting the sky. When it is as featureless as this it's a simple task for the Magic Wand tool. Make sure that the Add to Selection button on the Tool Options bar is selected. This makes it possible to add to the sky selection. You'll need to zoom in, as here, to ensure all the sky is included.

2 If the sky is problematic to select using the Magic Wand, use QuickMask to select the landscape instead. Ensure that the mask is well defined by zooming in and using a sharp-edged paintbrush to remove or add pixels to the mask respectively.

3 Open the new sky, click Select>All and Edit>Copy. Return to the original and select Edit>Paste Into. *Voila!*

RIGHT
It may be a true representation of the scene, but this sky is a bit lackluster and doesn't do justice to the subject.

FAR RIGHT
The new sky gives the image a much more balanced result, both in terms of composition and color.

TUTORIAL
Adding a sky behind transparent objects

1 With the last shot, the horizon was well-defined and the sky was continuous. This image is quite different, with the sky appearing through these sails.

2 To use either the selection tools or masking would be time-consuming and fiddly. By using Replace Color Range, we can select all these discontinuous regions at a stroke. Open the Color Range dialog (Select>Color Range) and click on the sky.

3 Zoom in and examine the boundary of the selections. Use Select>Grow to increase the selection by adding any transitional pixels that might otherwise leave a white halo around the areas of new sky. When you paste in the new sky (Paste Into), you'll have a convincing sky.

This windmill was shot on a sunny day, but to capture the detail the photographer had to expose for the stonework, giving an overexposed sky.

The final image looks natural. By using Color Range, you've placed the new sky behind the windmill's sails, which would otherwise have been laborious.

TUTORIAL
Replacing a sky and reflection in water

1 Here, we need to replace the sky *and* its reflection. We can replace the sky as before, but to create a reflected sky, we must first invert the same sky that we pasted in to provide the basis for the reflection. Use Image>Rotate>Flip Vertical. To make it look more like a reflected image, apply a ripple using Filter>Distort>Wave.

2 To select the water area to paste the sky, use the Magic Wand and QuickMask, and once done, paste the sky into the selection using Edit> Paste Into Selection. Cheat a little by using Edit>Transform>Scale to stretch the sky to fit. Dim the brightness of the reflection by using the Opacity slider on the Layers palette.

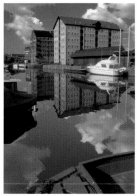

With a large desktop it's easy to move a replacement sky to a new position. Just make sure both images have similar resolutions.

With the reflection of the sky in place, the image becomes convincing. When constructing an image like this, be careful that the shadows in the clouds match those in the landscapes.

ISOLATING OBJECTS

WITH PHOTOSHOP YOU CAN USE YOUR OWN PICTURES TO SET UP A CLIP-ART LIBRARY—IF YOU ISOLATE THEM. THIS MEANS SAVING YOUR SKIES, ANIMALS, HOUSES, TREES AS CUT-OUTS, SO THAT YOU CAN ADD THEM TO OTHER PICTURES YOU TAKE IN THE FUTURE.

TUTORIAL
Adding a clip-art image to a picture

1 Isolate the owl in this photograph (taken at a wildlife park), and once isolated, you can add the image of the owl to this family scene. To be mischievous, how about on the head of the dog?

2 Different subjects need different kinds of cut-out. In the case of the owl, use the Magnetic Lasso tool for a crisp cut-out. There's no need to feather this selection as you want the feathers to be well-defined. It isn't 100 percent accurate, but this doesn't always matter. In cases such as this, no-one will know what the owl looked like.

3 Having made the crisp selection, open up a new document, and copy the owl (Edit>Copy). Photoshop opens the new document with a suggested size that matches the contents of the clipboard (that which you have just copied). Paste (Edit>Paste) and save the document as a layered Photoshop file (File>Save) with a suitable name.

4 Try to save your cut-outs big and at the highest-possible quality, even though you may not need that level of quality. As the background image is a small, compressed JPEG file, it is a little "noisy". Reduce its image size to one that matches its magnification for placement on the background. If it is still too smooth, use the Noise filter (Filter>Noise>Add Noise) to give it an equivalent "feel" to the image it is being pasted onto.

5 Now the owl is isolated, you can have fun with it. Here's a photo of some friends and a dog. One of the children was looking at the dog so paste the owl (which is still in the clipboard) onto the image. The owl is about twice as big as the whole image.

6 You'll see that there's a problem with scale here. The two images have different resolutions, so you need to reduce the size of the owl to make the scene realistic. Select Edit>Free Transform. Set the image scale to 25 percent in the Options bar. You can now fine-tune the size by using the drag handles on the corners of the image. To maintain the proportions, hold down the Shift key so that any changes will apply to both vertical and horizontal dimensions at the same time. Place the owl on the dog's head.

7 Click on Check to apply the transformation. This process—image montage—is one of the most powerful in image-creation, and we'll examine further methods later in the book.

Original image of the owl.

Original family portrait scene.

Owl isolated using the
Magnetic Lasso tool.

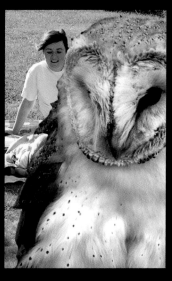

Owl being pasted onto family
portrait, prior to resizing the owl.

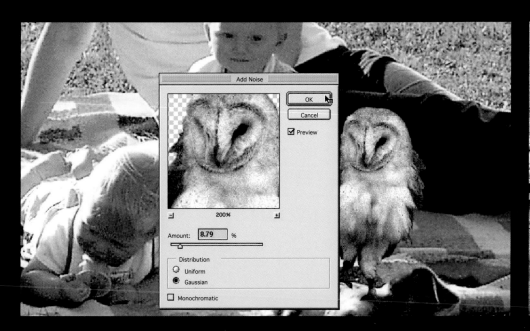

Adding noise to the owl image with the Add Noise filter
helps it blend better with the background.

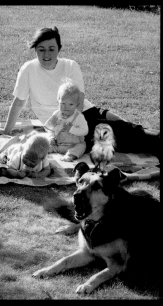

The final composite. Slightly
surreal, but in photographic
terms quite believable.

ADDING EMPHASIS TO A SELECTION

YOU'VE DISCOVERED HOW TO ISOLATE A SUBJECT AND CREATE AND MANIPULATE SELECTIONS. YOU CAN COMBINE THESE SKILLS AND USE THEM TO ADD EMPHASIS TO A SUBJECT. HERE ARE TWO IMPRESSIVE TECHNIQUES: THE VIGNETTE AND DESATURATION.

TUTORIAL
Creating a vignette

Popular since Victorian days, a vignette is literally a cut out through which the image is seen. In practice we generally interpret this as a soft-edged rectangle or ellipse that frames our image. Many art shops sell cardboard vignette frames that can be used as overlays but you can create your own very simply.

1 Select the Elliptical Marquee tool and set a feathering radius. The size of the feather will depend on the resolution of the image, but for a 4-megapixel image, start with a radius of 25 pixels. Draw the ellipse across the image so that it frames the main subject but leaves a modest margin around the edge of the picture.

2 Choose Select>Inverse to invert the selection and then press Delete. The surroundings of the ellipse will disappear and reveal the background color. Your portrait remains with a soft edge.

3 With black as the background color, this alternative effect results.

4 You don't need to use a regular shape for the vignette. Using the Lasso tool (again with a suitable degree of feathering), you can describe a non-standard shape appropriate to your subject.

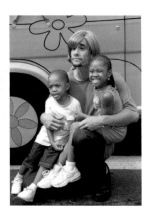

The original image.

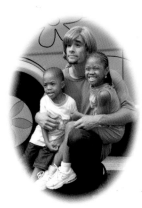

Vignette with white to form the background color.

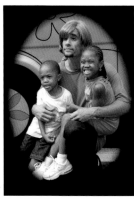

The effect looks quite different when you change the background to black.

This irregular vignette is created using the Lasso tool.

Our original, full-color image.

The emphasized image. Note how the color of the flowers has become less obvious.

TUTORIAL
Desaturation for emphasis

Adding a color element to a largely monochromatic image can have incredible impact. It's an effect that's not lost on movie makers and great photographers. Here's how to emulate the look.

1 In this image we'll retain the color in the subject and desaturate the background. Select the subject using the Magnetic Lasso, Magic Wand, or even the masking tools. The best result—given the shape and color—will probably be achieved with a combination of these tools.

2 Once the selection is complete, choose Select>Inverse (to make the background the active selection) and then Image>Adjustments> Desaturate. The color is immediately removed from the selection.

DEPTH OF FIELD AND ZOOMING
Depth of field effects and zooming are two more techniques for emphasis that you'll look at later (see page 122).

04

ADVANCED TECHNIQUES

The term "advanced" is used here with some trepidation as it can so easily be considered synonymous with difficult. That certainly is not the case. So far you've seen that it really is easy to create great images with just a few image-editing tools. Now it is time to consolidate what you've learnt, and expand your digital horizons.

Some of the techniques you'll examine are straight out of the conventional darkroom—dodging and burning, for example—along with grain and texture

Perhaps the best example of a case for understanding several digital-imaging tools is the restoration of old photos. You'll look at restoring both aged color and vintage monochrome photos. You'll discover not only how to make a contemporary photo look like a family heirloom, but how to give old photos

DODGING AND BURNING

MUCH OF THE CREATIVE EFFORT IN THE DARKROOM COMPRISED ENHANCING AN IMAGE BY HOLDING BACK OR INTENSIFYING THE AMOUNT OF LIGHT THAT HITS PART OF AN IMAGE: DODGING AND BURNING. YOU CAN BRING OUT HIDDEN DETAIL IN HIGHLIGHTS, AND AVOID SHADOWY DARK TONES USING THE DIGITAL DODGE AND BURN TOOLS.

RIGHT
Original shot, with a washed out sky and muddy foreground.

FAR RIGHT
With a little burning, the clouds become much more impressive.

When you select either the Dodge tool to lighten an area, or the Burn tool to darken, you have the benefit—not given to the darkroom worker, who would need to predict the effect of his or her actions—of being able immediately to see the result on the image. And, of course, you have the opportunity to hit the Undo option should the effect be too severe or inappropriate.

To use either tool, begin by selecting the tool and then a brush type. Dodging and burning should be subtle, so go for soft-edged brushes and set the exposure to 10 percent. It's better to build up the effect gradually than attempt to do it in one big hit. Both effects can have a very dramatic effect on your images if used at their default 50 percent setting.

TUTORIAL
Improving poor tonal balance

1 This original shot suffers, like many taken with basic digital cameras, from a washed-out (overexposed) sky and dark (underexposed) foreground. The metering has averaged the respective brightnesses to give a value that suits neither.

2 Select the Burn tool and use broad, overlapping strokes as you build density in the sky. Make sure that Midtones (in the Tool Options bar) is selected. It's better to build density gradually, using a low Exposure setting. Heavy, dark strokes, lack subtlety.

ᴲ The ship and buildings need to be lightened a bit. Use the Dodge tool in the same way as the Burn tool. Set the Tool Option to Midtones and the Exposure to a low value (5–10 percent).

Ч As you dodge the landscape you may find that the color becomes flat and pale. To a degree this is inevitable, but there is another option in the Dodge and Burn tool set: the Sponge. You can use this just as before to add (or remove, by choosing Desaturate from the pull-down menu in the Options bar) to the color saturation in selected areas.

Ƽ Once you are happy with the effects of using the Dodge and Burn tools, and the Sponge, save your changes.

MIND THE HIGHLIGHTS
When you use any of these tools there's an option to apply them to the Highlights, Midtones, or Shadows. Take care not to burn in the highlight regions, or you'll get an unpleasant "gray" effect on highlights that will leave your images looking flat. Highlights must be bright in the same way that deep shadows must remain dark.

ADVENTURES WITH COLOR

THERE ARE STILL A GREAT NUMBER OF PHOTOGRAPHERS WHO CONSIDER COLOR TO BE SUPERFLUOUS AND FRIVOLOUS. BY CHANGING THE COLOR OF YOUR PHOTOGRAPHS YOU CAN CAPTURE THE ESSENCE OF A SCENE AND CREATE STUNNING IMAGES.

TUTORIAL
Giving Mel's Diner Color Treatments

Mel's Diner (Universal Studios, Fl) is almost stereotypical of the genre, but makes for great photos. But despite the great color in the scene photos of subjects like this often fall—in color terms—flat. The combination of chrome and neon should be a photographers dream—let's look at two simple ways to make it so.

1 Analyze the original shot. Key color elements are the blue-green of the building, Barbie-pink neon and similarly colored Chevy.

2 What happens when we increase the color while leaving the image otherwise unaltered? Select Image>Adjustments>Hue/Saturation. Move the Saturation slider up until all the colors become bright. Doesn't this make the image more impressive? What has happened is that some of the bolder colors have become fully saturated: pure color and nothing else. This treatment would not work with many other types of image. Saturated color will look absurd on a landscape and unflattering in a portrait. But here it perhaps typifies the brash nature of the diner's architecture.

3 Is it the color that makes this shot? Let's reduce the color and see. Open the Hue/Saturation dialog again but this time check the small box marked Colorize. The image becomes toned, rather in the manner of a sepia-tone photograph. Move the Hue slider to alter the color and the Saturation

Mel's Diner photographed in the afternoon sun.

Hue/Saturation

Master ▲▼

 0

 OK

 Cancel

slider to vary the amount of color. In our selection
there is only a hint of color but even though the
image is, ostensibly, monochrome, it still has
presence. There is an almost metallic feel to the
image that, again, is sympathetic to the subject.

Bold coloration is an ideal treatment for this subject.

This treatment is really empathetic to the chrome elements in the scene.

SOLARIZATION AND SABATTIER

BOTH SOLARIZATION AND THE SABATTIER EFFECT ARE STRIKING, AND EASY MANIPULATIONS OF COLOR THAT YOU CAN USE TO CREATE INTERESTING IMAGES.

In color photography, the result of deliberate exposure of film emulsion to light produces unusual coloration, and images that are part positive and part negative. It is one of those darkroom effects that is comparatively easy to achieve and, unlike so many, reasonably reproducible. Once, solarized images were considered by photographers and their audiences as powerful and attention-grabbing. But under the onslaught of ever more bizarre and contrived digital techniques for creating potent images, they have slipped into relative obscurity. That's a shame because creating a solarized image digitally is really easy.

TUTORIAL
Starting solarization

1 Choose an image. Because of the strange coloration that results, it's best to choose still-life or landscape shots.

2 Apply the Solarize Filter by selecting Filter> Stylize>Solarize.

3 A straight solarized image has a heavy, post-apocalyptic look. Apply Image>Adjustments>Auto Levels to pep up the color to give a slight pop-art look to the image.

Starting point: it's colorful, but not impressively so.

The Solarize filter alone tends to give unusual, but rather dark results.

Adjusting the levels (here using Auto Level) injects a little more potency to the colors.

TUTORIAL
Using Sabattier to surreal effect

Similar—but not identical—to solarization is the Sabattier effect. In its digital manifestation, it is the result of grossly modifying the graph in the Curves dialog box. This graph determines the correspondence between color and tone in an original image and the way they are reproduced. By modifying this graph, color and tone can be drastically altered.

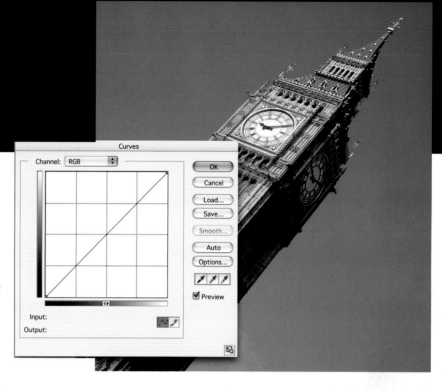

1 To create a Sabattier image open your image and select Image>Adjustments>Curves. Note that the graph line is a straight diagonal.

2 Click on the starting point of the graph and drag it to the top right corner. Click on the midpoint and pull the line down, giving a broad, "U" profile. This is the basic Sabattier shape. You can now adjust the detail of the curve until you get a strong graphic image (purists will say the shape of the curve needs to be precise, but don't let that get in the way of a great image!).

TOP RIGHT
The Curves graph in an image before adjustment is linear and diagonal.

BOTTOM RIGHT
For a typical Sabattier effect image, the curve is adjusted into this U-shaped catenary curve.

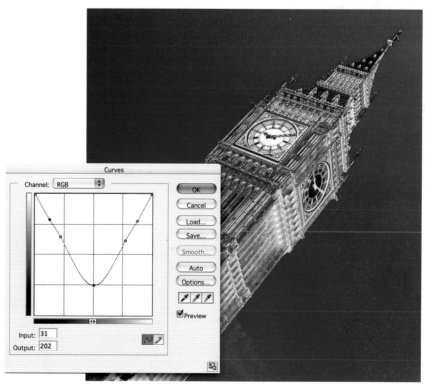

PANORAMAS: GOING WIDE AND TALL

DIGITAL CAMERAS BOAST SOPHISTICATED ZOOM LENSES. THESE MAKE IT POSSIBLE TO CLOSE IN ON SPORTS ACTION OR A DISTANT LANDMARK, BUT THEY ARE LESS EFFECTIVE RECORDING WIDE-ANGLE VIEWS. HOWEVER, DIGITAL TECHNIQUES COME TO OUR AID TO CREATE PANORAMAS.

Successful panoramas need some planning. Take the original photos of the panorama with the lens set to a focal length equivalent to around 70mm on a 35mm camera. At this focal length image distortions are kept to a minimum. Overlap adjacent images by 25–30 percent. When we come to join (or "stitch") our images this will provide sufficient overlap to ensure the software can identify common points in both images. The process is also made simpler if you take your photos in a clockwise direction and keep your camera level. A tripod (or sharp eye) helps here.

TUTORIAL
Creating a panorama

1 The panorama creating software in Photoshop is known as Photomerge. It appeared with the release of Photoshop Elements and made the jump to its sibling with the release of Photoshop CS. To open Photomerge, select File>Automate> Photomerge in Photoshop CS or File>Create Photomerge in Photoshop Elements. Use the Browse feature to select and import the images for the panorama.

2 Hit OK and Photomerge will begin analyzing your images. It will identify the order in which the images should be arranged (unlike some software applications that require images be placed in order manually) and determines how they should be merged. After a few seconds you'll see a preview like this. Should Photomerge be unable to join images you can manually move any errant images into place.

3 When you are happy with your arrangement press OK again. Photomerge will now produce a seamless panorama. This is an intensive task so it may take a few minutes, particularly if there are a number of images or if they are high-resolution images. Check the final image for abnormalities. Here a join has not been entirely successful. The difference in sky tones is obvious.

RIGHT AND FAR RIGHT
Overlapping adjacent images ensures an effective join when the panorama is compiled.

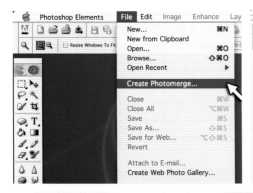

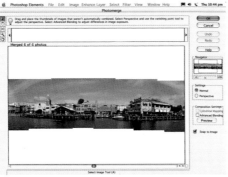

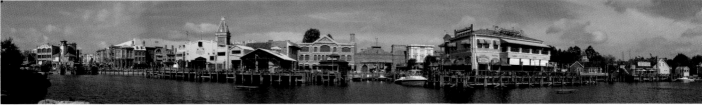

TOP LEFT
Select Photomerge
to begin the panorama.

TOP MIDDLE
When loaded into
Photomerge, a low-
resolution panorama
is created.

TOP RIGHT
Close inspection of the
panorama shows some
minor incongruities.

BOTTOM
When these transitions are
smoothed a perfect
panorama results.

4 Use the Clone tool (at an opacity of around 30 percent) to smooth out such transitions. You may also need to trim the top and bottom of the image. The original shots were hand-held and the camera was not completely level throughout. The result is a broad panorama that could otherwise only be produced by complex (and expensive) professional equipment.

ALSO CONSIDER...
Roxio Photosuite and other applications also include a similar feature. PhotoVista (also from Roxio) is a stand-alone application for creating panoramas.

GETTING SOME PERSPECTIVE

IF YOU'VE COMPARED YOUR PHOTOS OF THE MANHATTAN SKYLINE WITH THOSE TAKEN BY PROFESSIONAL PHOTOGRAPHERS, YOU'LL NOTICE THAT THEIR BUILDINGS STAND TALL WITH TRUE VERTICALS WHERE YOURS SUFFER FROM CONVERGING VERTICALS.

A typical architectural shot from a regular camera. Note how the building narrows with height.

Use the Crop tool to align the edges of the image with the verticals of the building.

When the crop is actioned the correct geometry results.

TUTORIAL
Squaring up architecture

The professional photographer has the benefit of using specialist lenses or cameras to capture the full height of a building. The digital darkroom contains a tool that can correct convergency in your photos and give you geometrically perfect images just like the pros! The tool that achieves this is nothing more mysterious than the Crop tool.

1 Here's an example of a photo that suffers from converging verticals. Though the photo was taken from some distance away the camera still needed to be pointed upward slightly and hence the effect.

2 Drag the Crop tool across the image so that the entire image is selected. Check the crop in the Perspectives box which appears in the Crop tool Options dialog. The crop line features small boxes —handles—at the corners. Click and drag these corners so that the sides of the cropped selection appear to converge at the same distant point.

3 When you hit OK to apply the crop, the image will be stretched back to its original size and shape, correcting for the convergency. Simple, but effective.

This photo was originally taken as a character study of the painter.

Releasing this artwork is comparatively simple using the Crop tool.

TUTORIAL
Creating new pictures from old

1 You can be even more creative with the Crop tool and isolate image elements that may show perspective effects in more than one direction. By dragging the Crop tool over the painting in this image we are able to produce a perfectly proportioned shot as if we were standing squarely in front of the canvas.

2 The corners of the Crop tool have been dragged to the respective corners of the painter's canvas to produce this perfectly proportioned representation of the painting.

GRAIN AND TEXTURE

IRONIC, ISN'T IT? FILM TECHNICIANS HAVE SPENT MILLIONS OF DOLLARS TO MAKE GRAIN VIRTUALLY INVISIBLE ON CONTEMPORARY PHOTOS, YET GRAIN EFFECTS REMAIN POPULAR AND ARE OFTEN ADDED TO DIGITAL IMAGES TO CREATE ATMOSPHERE.

LEFT
The original portait.

TUTORIAL
Adding noise to enhance a portrait

1 Adding grain is a simple process and Photoshop provides two options, both found in the Filters menu, and it is worth trying them out to gauge the different effects you can achieve. Use it on images such as this.

2 Add noise (Filter>Noise>Add Noise) to give a uniform speckled "noise" that is very similar to film grain and is very effective for shots where the image may not be technically perfect, too. You can vary the amount of noise added and also the type. Check the Monochromatic box to prevent polychromatic noise, which is much denser, and overly distracting in some images. Next, select the Gaussian option to give a softer grain structure that is subtler than the default option.

3 Monochromatic noise produces a result closer to film grain than polychromatic, as we can see from the close-up, below.

4 Try out the second option, Grain (Filter>Texture> Grain) which offers a range of graining options that include Regular, Soft, Clumped, Contrasty, Horizontal, and Vertical.

Adding noise to the image can produce a more "reportage-style" look.

Using the Grain option gives a more powerful portrait.

There are a range of grain effects which mimic film grain for a "gritty" look.

The original photograph of this restaurant. Color has been reduced using the Saturation control.

The effect of horizontal grain gives this image an antique, "distressed" look.

TUTORIAL
Adding grain for a distressed look

1 This image of a Victorian building is an ideal candidate for applying a distressed, grand look.

2 Select Filter>Texture>Grain and choose Horizontal from the range of graining options. Click OK to apply horizontal grain to the whole image to produce a uniform, graduated distressed look to the photograph.

TUTORIAL
Applying texture

More obvious than grain, textures have long been a popular way of print finishing. In the good old days texture screens (transparent, textured sheets) were placed over an image in an enlarger. Now we can apply texture using one of Photoshop's Texture filters. Craquelure is a favorite that, unlike many filters, doesn't become clichéd with repeated use.

1 Select Filter>Texture>Grain and choose Craquelure from the range of graining options.

2 Click OK to apply the Craquelure effect to the image and to produce a uniform "cracked" look to the photograph which is very effective.

The Craquelure filter is a great way of adding instant texture to an image, and is often more effective than canvas textures, especially when printed on matte paper.

IMPROVING PORTRAITS

PORTRAITS ARE OFTEN THE MOST EMOTIVE OF PHOTOGRAPHIC SUBJECTS. IT IS EASY TO IMPROVE UPON BASIC FLAWS IN YOUR DIGITAL PORTRAITURE OR YOUR SUBJECTS.

TUTORIAL
Creating sparkling eyes

They say that eyes are the windows to the soul. Whether or not you believe that there is no doubting that subtle manipulation of a subject's eyes can sometimes achieve more than dramatic digital surgery elsewhere on the face. Brightening the eyes can, at a stroke, take years off a subject and make for a warmer expression.

1 Here's a great portrait but you can now make it even better.

2 Begin by selecting the whites of the eyes with the Magic Wand and brightening them. Use the Dodge tool set to an exposure of 10 percent is best for this. Don't overdo it. Too much brightening can give your subject a very strange appearance.

3 Dark brown irises can often become near-black and featureless. Use the Dodge tool again (this time set to about 5 percent) to lighten them slightly and restore some of the detailing. Next, increase the saturation. You could use the Sponge tool or else, as here, apply an increase of 5 percent in saturation to the selected iris with the Hue/Saturation dialog. Again, take care not to overdo it. It helps if you zoom out periodically to check the look of the whole face.

4 As a final flourish, give your subject a little catchlight. Professional portrait photographers often use special flash lights to give a catchlight—a small bright highlight that gives the eye "sparkle". We can do much the same using the Paintbrush tool.

Select a fine, soft-edged brush and apply white paint at 70 percent opacity. Build up the density with repeated applications for a stronger effect. Suddenly your subject's eyes have that special glint and a good portrait becomes a great one.

5 Compare your end result with the original. Certainly a case of making a good thing better.

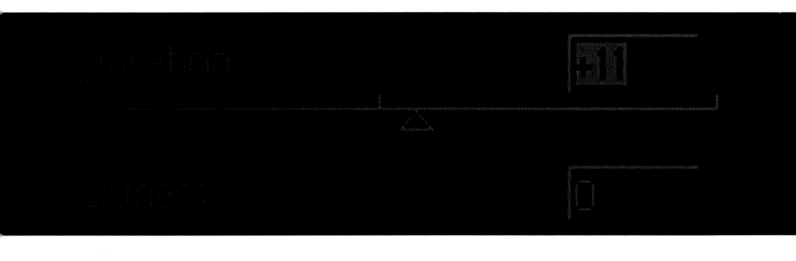

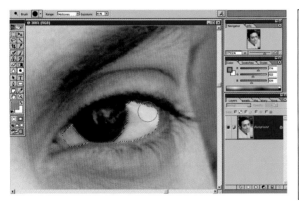

PORTRAIT TIPS

■ Take a cue from professional photographers and use soft-focus techniques to add romance to your portraits. The soft mistiness hides fine blemishes but doesn't cause deterioration.

■ Use the same technique as shown to improve teeth and make them brighter. In this case don't be so extreme with the lightening effect or you'll get a quite unnatural effect!

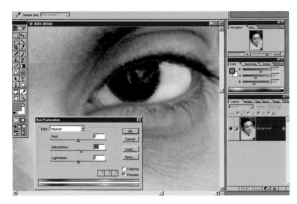

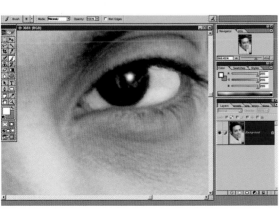

FACING OPPOSITE
Original portrait: it's good, but lacks "punch".

TOP LEFT
Gentle use of the Dodge tool increases the whiteness of the eyes.

MIDDLE LEFT
Eye color is easily lost, or can become muddied. Correcting it is essential to creating a great portrait.

BOTTOM LEFT
The sparkle in an eye helps lift an ordinary portrait into a special one.

LEFT
Just these few subtle changes have transformed the portrait.

CREATING HIGH-KEY PORTRAITS

ANY PHOTOGRAPH IN WHICH THE TONAL RANGE IS STRONGLY BIASED TOWARD LIGHTER TONES IS DESCRIBED AS "HIGH KEY". USUALLY THE TERM IS RESERVED FOR PORTRAITURE WHERE THE RESULT OF CHANGING THE TONALITY IS A BRIGHT, DELICATE, AND MORE FEMININE LOOK.

TUTORIAL
Adding definition to a high-key portrait

Often photographers can achieve high-key results in-camera but it is possible to give a high-key effect to just about any portrait. Couple this with soft-focus techniques and we can achieve the ultimate in flattering portraiture!

1 Begin by making any basic image edits that are required on the image. These might include cloning over spots and blemishes or removing any distractions in the background. Although you will lessen the impact of the background later, it is still worthwhile removing any overt elements.

2 To change the tonal balance, use the Levels dialog box. Select Image>Adjustments>Levels and move the Black Point slider to the left. Take care not to slide it too far. Though this will brighten the image, it risks losing detail in the highlight areas. Move the Gray Point slider (which represents the midtones in the image) to the left, to lighten them.

3 The image has been dramatically lightened compared with the original, but is still not high-key. Use the Dodge tool (with a large, soft-edged brush selected) at an exposure of around 20 percent to lighten the surroundings of the face. You could be more dramatic here and apply a vignette and remove the background (or in this case the extraneous hair) entirely.

4 Now you need to attend to the details. In high-key portraits, light tones predominate but that does not mean there are no intermediate or darker tones. At the moment, the portrait features only light tones. Use the Burn tool to burn in the eyes, lips, and selected parts of the hairline. This will help emphasize the overall lightness of the face and give the image a more balanced look.

5 The finished portrait shows feature definition that stands out from the high-key effect.

LOW-KEY PORTRAITS
Perhaps obviously, creating a low-key portrait involves making dark tones dominate but ensuring that there are still light and midtones. In this case ensure that the eyes and teeth particularly do not become darkened.

FAR LEFT
Our original portrait: sharp and well-exposed. Just a couple of blemishes need attention.

LEFT
Level adjustments bring an immediate lightening of the image, but the technique is indiscriminate.

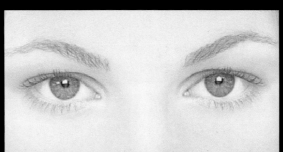

FAR LEFT
The Dodge tool corrects (or enhances) tonal variations.

LEFT
The Burn tool further enhances variations.

LEFT
The final image: high-key has given a more romantic (and flattering) effect.

SOFT FOCUS

SOFT FOCUS IS OFTEN USED ON PORTRAITS BECAUSE IT GIVES THEM A FLATTERING, ROMANTIC LOOK, AND HIDES MINOR IMPERFECTIONS SUCH AS FINE WRINKLES OR RED VEINS. THIS PROCESS IS A GREAT ONE TO USE ON PORTRAITS, STILL-LIFE PHOTOS, AND EVEN LANDSCAPES WHERE YOU WANT A DREAM-LIKE QUALITY.

TUTORIAL
Using soft focus on a portrait

Soft focus relies on combining two versions of the same image: one critically sharp, the other blurred. Traditional photographers resort to expensive soft-focus filters and soft-focus lenses. You can take a more economic digital route to get the same effect.

1 Soft-focus manipulation is something that should be performed after other image-editing actions. If you are applying it to a portrait, as here, use the Clone tool to remove any blemishes first and enhance the portrait (if required).

2 Create a copy of this image in a new layer by clicking Layer>Duplicate Layer and OK.

3 Apply a Gaussian Blur to this layer. Choose Filter>Blur>Gaussian Blur and set an appropriate amount of blur. This amount will depend upon the subject and also on the size of the image. Aim to set an amount that blurs the detail of the image but still leaves the image (and particularly the subject) recognizable.

4 Move the Opacity slider in the Layers palette to the left. Best results will be when an opacity of between 40 and 60 percent is set. Changing the opacity like this enables the original sharp background to appear through the softened layer, producing a result which is both commendably sharp with softened detail.

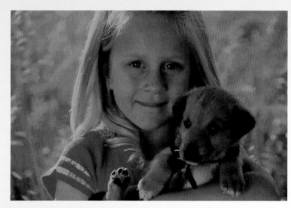

The original image has been enhanced by removing background distractions.

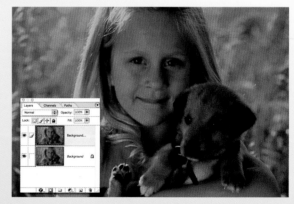

When we create a new duplicate layer there is no obvious change to the layer itself.

After applying the Gaussian Blur filter the image
becomes very obviously blurred.

It is the subtle adjustment of the Opacity setting that
delivers the soft focus result: you can adjust at will to
get a great result.

SOFT-FOCUS TIPS

■ Applying soft-focus is a great way of getting good portraits
from low-resolution or small originals. The softening effect
masks the artefacts and grain of the original.

■ You can vary the amount of softness by creating a second
layer, copied from the soft focus layer. Select the soft focus
layer and then choose Layer>Duplicate Layer. Vary the opacity
as required. Changing the Blend mode in this second layer
(using the pull-down menu on the Layers palette) can also
produce intriguing results.

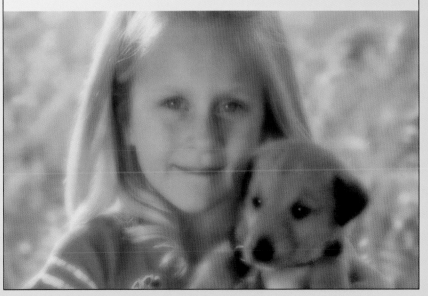

Soft focus works well with high-key effects, and, using different blend modes,
you can produce dramatically different results.

REPAIRING OLD PHOTOS

RESTORING OR REPAIRING A DAMAGED OLD PHOTOGRAPH CAN BE A SENTIMENTALLY SIGNIFICANT BUT PRACTICALLY SIMPLE EXPERIENCE USING PHOTOSHOP.

Before you restore an image you must study it and examine precisely what needs attention. The ravages of time inflict damage in quite different ways and each degradation needs its own specific treatment.

The most common problem is physical damage. Photographs that have spent many years being passed around family members, placed in folders, or left in drawers, will suffer wear and tear. Corners, particularly, become worn and can often break away entirely.

Photos are also prone to fade. It's not just sunlight that can cause fading: chemicals in the environment and even those in the paper used to create albums can cause fading in the long term.

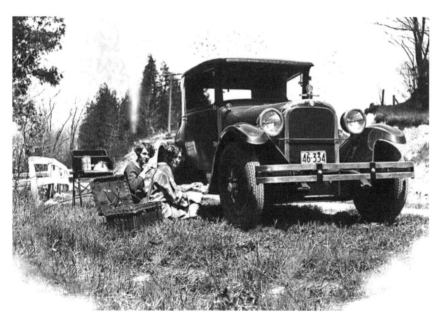

Time, pollution, and poor handling have together compromized this 1920s' photo.

It's important to be gentle with restoration work, as here, cloning away superficial damage.

TUTORIAL
Restoring a damaged, old photo

1 Like many well-loved images this photograph has suffered a great deal of abuse but is by no means beyond repair. An assessment shows the image to have faded. Corners are worn, and there is a fold down the middle. Looking more closely, you see that there is mold and fingerprint damage, most obviously in the sky area. And, to cap it all, the image is rather soft, probably because it was taken with a cheap Box Brownie camera.

2 You can start hiding the tear and damage to the sky area by brushing over the mould and using the Clone tool to repair the tear where it crosses into the tree growth. When correcting the sky in an image like this, resist the temptation to paint over the sky with white paint. Instead, sample the color of the sky using the Eyedropper tool and paint with this.

3 Repairing the missing corners seems a rather daunting task but fortunately you can use some of the adjacent grass and undergrowth to fill these areas. To avoid the cloned area looking too similar to the original grass, change the "clone from" position periodically. The result is then more random, and significantly more natural.

4 Your transformation is now almost complete. Use the Brightness/Contrast dialog (Image> Adjustments>Brightness/Contrast) to increase the contrast until you get a good black in the darkest part of the image. Call it cheating, but you can use the Auto Levels command (Image>Adjustments> Auto Levels) to get a good tonal spread.

5 And, to improve on the original, apply Filter> Sharpen>Unsharp Mask to give the photo a sharpness that the original never had.

Even "missing" parts of an image can be restored using similar textures and image elements.

After restoring the tonality, you really can achieve a result that is as good as the original would have been.

CREATING AN AGED LOOK IN PHOTOS

NOW WE KNOW HOW TO RESCUE A BADLY DAMAGED OLD PHOTOGRAPH, HOW ABOUT MAKING A CONTEMPORARY IMAGE LOOK OLD? HERE'S HOW TO MAKE A PHOTO THAT MAY HAVE BEEN TAKEN YESTERDAY LOOK AS IF IT WAS TAKEN IN A BYGONE AGE.

TUTORIAL
Applying tone to an image

It is easy to create a digitized antique effect by adding a sepia tone, which mimics the amber toning of early film chemistry.

1 Creating a sepia-toned print is simple. Open the Hue/Saturation dialog box (Image>Adjustments> Hue/Saturation) and check Colorize. Move the Hue slider until the image is a sepia color. You'll find that it reduces the saturation a bit and increases the brightness. This helps enhance the faded look that is also common in genuine sepia-tone prints.

2 Add to the look by adding a white border. Make a selection around the portrait and invert it (Select> Invert). Then press delete to reveal the surround.

RIGHT
This low-key portrait is ideal for toning.

FAR RIGHT
Adding a vignette border as well as toning delivers a result that emulates a treasured Victorian photograph.

FAR LEFT
The original image of contemporary Main Street USA in all its colorful glory.

LEFT
With a few judicious selections—removing the blue and green in the image—we create an antique effect for a true-blue Americana treatment.

TUTORIAL
Splitting channels

For a more authentic aged effect, you need to emulate the way traditional film emulsions were used. These tended to be quite different to the panchromatic emulsions that are used today and generally had a higher sensitivity to red light, at the expense of blue.

1 You can recreate this by splitting an image into its constituent color channels. Click on the Channels tab on the Layers palette to display the channels (or select Channels from the View menu) and choose Split Channels from the pullout menu. This produces three images (in red, green, and blue light) from the original.

2 Discard the blue and green and apply a grain effect to the red channel. Finally, do an Image>Adjustments>Brightness/Contrast command, then boost the contrast by about 10 percent.

In this color original, this elderly Native American looks contemporary, but...

...by discarding the blue and green from the original, we can age the image to make it look antique.

The final, red-only image, with a subtle grain added to complete the effect.

TIP
■ **Deliberate ageing can produce very authentic results, just watch out for anarchronisms, such as modern cars or street furniture.**

HAND-TINTING A BLACK-AND-WHITE IMAGE

SINCE THE EARLIEST DAYS OF PHOTOGRAPHY, PHOTOGRAPHERS HAVE INDULGED THEIR ARTISTIC SIDE IN HAND-COLORING BLACK-AND-WHITE IMAGES. HAND-COLORED IMAGES CAN STILL BE EFFECTIVE AND ARE EASILY ACHIEVED.

Today hand-tinting is rare but the technique is still a great way to rejuvenate heirloom photos. When you undertake tinting, you need to follow in the footsteps of those early photographers and use dyes to color your images rather than pigment-based color. Like paint, pigment color is opaque and would obscure any detail in the original image.

TUTORIAL
Adding color to a monochrome image

1 First create a duplicate layer of the image. The image here is the same one we have already restored, except with this exercise, you make use of Photoshop's blend modes.

2 Begin by selecting a color for, say, the grass. There is no right and wrong for this process, so if a color looks right, it probably is. Paint liberally over the grass. Don't worry if you are not precise; a little overpainting adds character. Once complete, select Color Blend in the Layers palette. Immediately you'll see your painting has become tinted.

3 Next, color the sky. Don't be tempted to use an even blue here, even though the current sky is an even shade of gray. Think about real color images and real-world situations. A clear blue sky will be darker toward the top of the image and lighter at the horizon. Use the Lasso or Magic Wand to select the sky and apply a blue-to-light-blue gradient. Follow with the Color Blend mode.

4 For other parts of the scene, you have to use a combination of skill and judgement. You can aim for authenticity in skin tones, for example, but for the color of the car, you can be more inventive. This deep red looks quite convincing and sets off the other colors well. Apply, using the Lasso or Magic Wand tool, then Color Blend, as before.

5 Once all parts of the image have been tinted you need to examine the image again. Using the Opacity slider on the Layers palette you can adjust the opacity of the layer—effectively, the amount of color added. Here's your final image at 100 percent and 60 percent opacity.

SUCCESSFUL TINTING
Remember: avoid the brighter colors where errors are more obvious. Also, reducing the opacity helps make results look more authentic. For a different approach, try tinting just one part of the image—the principal subject, for example. This adds emphasis and emulates a technique that digital imaging experts like—desaturating color in an image background.

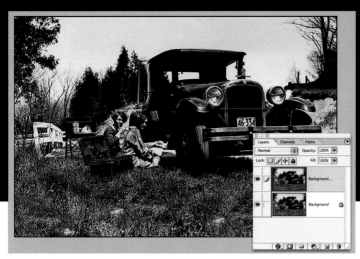

The rescued photo was originally black and white, but how about improving on the original by making it color?

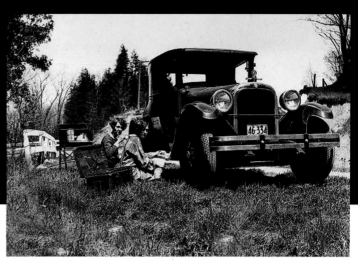

Coloring the grass should be done judiciously. An overtly green color risks looking too garish.

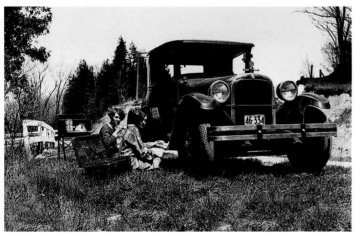

Skies are never an even shade of blue. A gradient (with the lighter color toward the horizon) is more realistic.

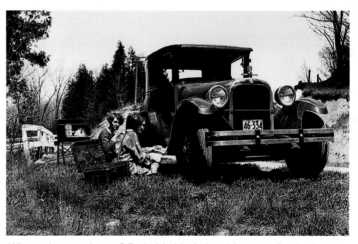

What color was the car? Probably black, but this maroon color is more visually interesting.

The final colored image with colors at 100 percent opacity.

Reducing the opacity (here to 60 percent) can sometimes improve the appearance (particularly in older photos).

05

USING LAYERS

Before image-editing software gave us layers,
our creation of complex images was rather
compromised and restricted to placing one element
over another. You could not determine how
elements would interact with each other.

Layer-technology changed all that. With a layered
image, you can build up an image rather like a

When you revisit your image and decide that
the pixels on a particular cell—which comprises a
layer—are inappropriate, or need changing, you can
do so without compromising the entire layer. Even
complex montages can be dissected and rebuilt.
The greatest significant advance in digital image

WORKING WITH LAYERS

LAYERS ARE THE BASIS FOR ALMOST ANY WORK YOU WANT TO DO IN PHOTOSHOP. IF YOU WANT TO BUILD AN IMAGE, YOU NEED LAYERS. IT IS INDISPENSABLE FOR YOUR CREATIVE IMAGE-MAKING.

Using Layers

To change a layer you need to make the one you are currently using active. Do this by simply clicking on it in the Layers palette. The layer selected is shown with a blue background.

When we make a selection, whether from the current image or another, and paste it into the image, a new layer is created. If the paste is from another image it may reproduce smaller or larger when pasted into the new image. This is because all layers in the image have the same resolution; if your incoming image element is of a different resolution it will be rescaled proportionally. You can alter the size of the element using the Edit>Transform command. Layers can also be turned on or off.

BELOW
You can achieve great effects combining text with images using Layers.

BELOW RIGHT
Create stunning vignettes with the Layers palette.

Special Layers

You'll come across some specialized forms of layers:

- Adjustment layers permit adjustments to the characteristics of underlying layers without permanently changing those layers. Turn off the Adjustment Layer and the alterations to color, color balance, levels, or whatever, are canceled.

- Layer masks are masks linked to a layer that determine what pixels in a layer (other than the background layer) are displayed or hidden. Hidden pixels will reappear if the layer is turned off.

- Text layers. When we add text to an image it will appear in its own layer. This is not pixel-based, thus, unlike other image elements, if we enlarge the text the pixel structure does not become visible.

THE LAYERS PALETTE

The key features of the Layers palette include:

■ Layer icons: show the layer construction of the image. The little "eye" icon to the left shows that the layer is visible. Click on this to toggle the layer on and off. The active layer is shown with a blue background.

■ Layer controls: comprising the Opacity slider (move this to increase or decrease the transparency of the layer); the Blend Mode pull-down menu (to change the Blend mode of the current layer); and Preserve Transparency (to prevent pixels painting on transparent areas).

■ Buttons: ranged along the bottom of the palette are shortcuts for creating a new layer, removing a layer (trash icon) creating an adjustment layer, layer mask or layer style.

CREATING A CONVINCING MONTAGE

SELECTING AND COPYING PARTS OF ONE IMAGE AND PASTING THEM INTO ANOTHER IS A SIMPLE PROCESS. BUILDING A COMPOSITE IMAGE MONTAGE REQUIRES MORE WORK BUT IS STILL EASY TO ACHIEVE. DISCOVER SOME OF THE VISUAL CUES WE CAN USE.

TUTORIAL
Using Layers to create a montage

1 The harlequin in this Venetian scene is well-framed, well-exposed, and pin-sharp. But it is difficult to pay attention to the subject because of the distracting background. You could employ digital tactics to reduce the prominence of this background. Blurring the surroundings might help, but there are simply too many colors and textures. Cloning, too, would be ineffective, as there is not enough material to clone from. Fortunately, we have some other images taken at the same time in which we could pose him.

2 This is the scene we want to display our character. The podium is ideal, and the two other characters will, if blurred, add to the scene without distracting from it. A little cloning will remove the passers by.

3 First select the harlequin. Use the Magnetic Lasso to cut out the basic shape. Switch to QuickMask mode to add in areas of low-contrast, particularly the black diamonds, and trim away others to make a clean edge. Save the selection as an alpha channel periodically so that your hard work is not compromised if you make a mistake.

4 In your new composition, you'll have a better result if the harlequin faces in the other direction. Save the selection (Select>Save Selection) and copy it to a new layer, and then Edit>Paste. To turn it around, select Edit>Transform>Flip Horizontal.

The original Harlequin.

The background for the montage.

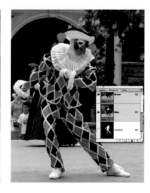

Harlequin selected (using QuickMask).

The cut-out (and reversed) Harlequin.

TIP
■ When resizing a selection to fit a
new image, it is better to make the
selection smaller than larger. It maintains
the image resolution and detail. If you
need to make a selection larger, it is
more effective, and more convincing,
to make the new image smaller.

5 Open the new image and paste the reflected
character into it. Do this by dragging the layer
containing the harlequin from the original image
to the new. Fortunately, the selection is the right
size and scale. If it were not you would need to
use the Transform command again (this time
with the Scale option) to alter the size to fit.

6 The result is already convincing, but something
isn't right. Take a look at the harlequin's feet.
He isn't casting a shadow. A small point, but one
that threatens to destroy the illusion, and one that
might be spotted instantly. Select the Burn tool
from the toolbar, a large diffuse brush, and set
the tool opacity to around 25 percent. Then click
the background layer and paint over the ground
beneath and around the subject's feet.

7 Blur the background to emphasize the subject.
You don't want to add too much blur because the
ground on which the harlequin is standing would
look odd. Switch to QuickMask and draw a gradient
from the top of the image to just behind his feet
(make sure you still have the background layer
selected). Return to Normal mode and apply a
Gaussian Blur (Filter>Blur>Gaussian Blur).

Initial montage.

*With shadows added to
improve authenticity.*

*Blurring the background adds depth of field and
emphasis to the main subject.*

TUTORIAL
Copying your subject into a new image

In the harlequin montage we were fortunate that both original images were taken at the same time, with the same camera, and that the lighting conditions were similar. The issue of varying color casts, light, or any other variables, weren't applicable. Yet none of these should pose too much of a problem. Create another montage, this time setting the central character against a range of settings.

Taken with good, diffuse lighting, and subtle fill-in flash, this portrait is ideally exposed—but the background of a pool and lanai is less impressive.

1 Select Magnetic Lasso to select the little girl from this setting. Switch to QuickMask mode to check the effectiveness of the selection. If there are any missing parts, use the paintbrush on the QuickMask to add them to the selection.

2 All details on the parasol were not originally included in the selection because the color was too similar to the background sky. Fine attention in QuickMask corrects the selection.

3 Copy and paste the selection into a new layer. Click on the small eye icon next to the layer in the Layers palette to turn off the visibility of the background layer. Viewed in isolation, it becomes easier to see any irregularities in the edge of the selection. Use the Eraser tool to remove any you find, gently rubbing at any pieces of the background that might also have been selected.

4 Once you are happy with your selection, prepare the new background. This simple, uncluttered scene is a good choice; it will complement, rather than compete with the subject.

5 Drag and drop the layer with the girl on to the new background. You may need to alter the scale of the image to make it compatible with the new one. In this case, no adjustment is necessary. Add shading to the new background to simulate shadows. As the light is coming from the right, the shadows trail off to the left. Use the Dodge tool (set to an exposure of 20 percent) to lighten one side of her face.

A charming character portrait: shame about the background!

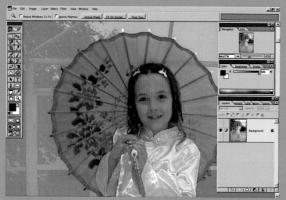

QuickMask is ideal for creating very precise selections.

The girl separated from her background.

Our new background.

The completed montage.

> ### TIP
> ■ Here the girl here is standing on grass. Using the Eraser tool small amounts of the feet were erased to make it appear as if she is standing in, rather than on, the grass.

TUTORIAL
Experimenting with backgrounds

Now that you've got to grips with the principle of montage, it becomes simple to slot images together. Here are a couple of further examples using the girl with the parasol.

1 As an alternative to the simple background of your first example, choose something in keeping with the girl's oriental-style dress—a Chinese temple, for example. The colors in this photo are rather warmer than the first, so you need to change the color balance to make the girl look less "cold." Color imbalances are often the most obvious cause of problems in composites. Use the Hue/Saturation command to increase saturation by 10 percent, and then move the sliders in Color Balance (Image> Adjustments>Color Balance), to increase the bias toward red and yellow.

2 Our subject is now standing in the Forbidden City in China. (In fact, it's only inches high, and called "Splendid China" in Kissimmee, Florida). This time, apply a shadow effect and enhance depth of field by using a Gradient mask and Gaussian Blur filter.

3 With this final image in the series of Splendid China images, success relies on making sure you place the two children in the image so that they appear to be interacting.

FAR LEFT
An alternative (and appropriate) background.

LEFT
The resulting montage.

Same girl, this time in the Forbidden City...

...and on the Great Wall of China!

IMMERSIVE MONTAGE

IN THE LAST EXERCISE WE SET OUR SUBJECT AGAINST DIFFERENT BACKGROUNDS, BUT IN REAL LIFE WE DON'T FIND SUBJECTS IN FRONT OF A LANDSCAPE. RATHER THEY ARE PART OF IT. SO HOW CAN WE PLACE A SUBJECT INTO A SCENE? THE ANSWER IS LAYER MASKS.

TOP
Photoshop automatically places new image elements in a new layer.

MIDDLE
The Layer Mask button at the bottom of the palette is the easiest way to add a Layer Mask to a layer.

BOTTOM
Paint the mask with Black paint where you want the layer (the girl) obscured.

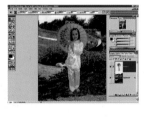

TUTORIAL
Using Layer Masks on a subject

Once you've got to grips with the principle of montage, it is simple to slot images together. Layer Masks can be used to hide a layer, group of layers, or selected parts of a layer. Rather like a QuickMask, you can use black paint to hide parts of the layer, white to show them, and grays to make the layer visible with varying transparency. Here is an example of how to place the girl with the parasol within a landscape by virtue of Layer Masks.

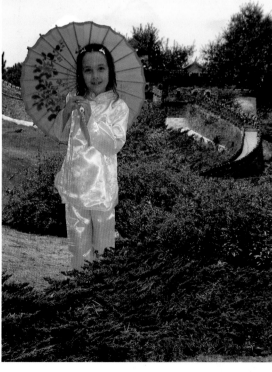

1 Begin by pasting the girl onto the landscape, which automatically creates a new layer. She is standing, rather incongruously, on some foreground foliage. To make the effect more convincing, it would be better if she is featured standing behind it.

2 Click on the Layer Mask icon at the base of the Layers palette to add a layer mask to the layer.

3 Use the layer mask to hide those parts of the girl's feet and legs that should, visually, be hidden behind the foliage. It's hard to be precise, so use the opacity slider on the Layers palette to reduce the opacity of the layer. This makes the layer become transparent, and helps you decide where to paint the mask much more easily.

4 Paint the mask over the areas you want to render invisible. Use a large brush size for the main areas and then a smaller brush for the detail. Once complete, return the opacity to 100 percent, and check the results. No-one would realize that she was never really there.

LEFT
Though the girl is on top of the background (in Layer terms), she appears embedded in the landscape.

TUTORIAL
Using Layer Masks to insert an object

1 Position your hand as if it were holding the chosen object (by a chosen object I mean something you could have actually photographed, a scanned image from a magazine or, if you are aiming for fantasy, a person, or even a building.

2 Add the object to be held in a new layer and use the transform tools (Edit>Transform>Scale, Rotate, or Perspective) to change the position and perspective to match that of the hand.

3 Add a Layer Mask to this layer and use the opacity control to determine which parts of the layer need to be masked.

4 For the finished image we've also added a new background layer and applied a mild color gradient.

An empty hand in an (admittedly) contrived position.

Use the range of Transform tools to get the size and position correct.

Vary the Opacity control to best assess the areas requiring masking.

The finished composite.

THE EXTRACT TOOL

THE KEY TO GOOD MONTAGE IS AN ACCURATE SELECTION OF THE SUBJECTS THAT YOU WANT TO TRANSPOSE FROM ONE IMAGE TO ANOTHER. THE KEY SELECTION TOOLS—MAGIC WAND, LASSO, QUICKMASK *ET AL*—MAKE A DARNED GOOD JOB UNDER A WIDE RANGE OF CIRCUMSTANCES, BUT EVEN THESE CAN BE FOOLED.

Subjects with indistinct edges, or edges with fine detail, can be problematic. Even if you use the Feather command to soften the edges of your selection you get a poor edge. To make light work of difficult selections, the Extract command is very useful.

TUTORIAL
Using the Extract command

1 This girl should be a simple subject—but for her hair! This would be problematic for conventional selection tools, even the catch-all, QuickMask.

2 Select Filter>Extract, and the image will appear in the Extract tool's own window. Tools arranged on the left of the window are for refining the final extracted image, while controls to the right are concerned with making the selection.

3 Use the Highlighter pen to draw around the edge of the subject. It's important that you adjust the width of the pen so that in areas like the hair, all the stray hairs are selected, along with the inner edge (that is, the solid area of the subject).

4 Important: with the Eraser tool, deselect those parts within the outline that should not form part of the ultimate selection. The areas enclosed by the arms, for example, don't need to be selected. When the selection is complete, use the Flood tool to color the enclosed area to verify that you've selected the whole of your intended area.

5 Click on Preview to view the selection to make sure that the tool has performed.

6 If it's not perfect, you can add better definition to translucent edges by using the Mask modification tools. Using one of these tools, rub gently over the boundary transitional areas until the selection is complete.

7 Place the extracted subject against a bright lemon gradient. With conventional selection techniques, you would either have a sharp edge to the hairline, or pieces of blue background appearing in the hair. But here, you end up with a clean, true selection.

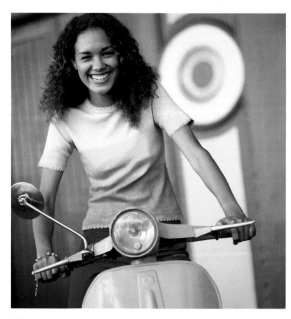

We want to extract this girl and her bike from the distracting background.

The Extract Command dialog.

Draw around the perimeter of the selection.

The Flood tool fills the selection—useful for checking the extent of the selection.

The first attempt may not be too precise. Note the poor edge quality.

Mask modification tools help refine the selection.

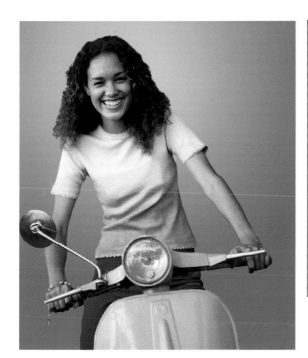

Against a new background, the effectiveness of the selection is clear.

EXTRACTION TIPS

■ Use a soft brush with the Eraser tool to remove any remaining edges that the Extract tool may fail to remove. A gentle brush around the edges will help the selection blend with any new background.

■ Try and keep the Highlighter as narrow as possible. Avoid using a very wide brush and drawing a cruder outline—the extraction will be less effective.

■ You can vary the width of the Highlighter pen if you need to—for example, you could have used a finer brush to isolate the handlebars of the scooter.

BLEND MODES

IN THE CONVENTIONAL DARKROOM COMPOSITE IMAGES COULD BE PRODUCED BY SANDWICHING TOGETHER TWO ORIGINALS. YOU CAN DO THE SAME THING WITH DIGITAL IMAGES, BUT YOU HAVE MUCH MORE POWER AND CONTROL OVER HOW YOU MAKE THE TWO IMAGES INTERACT.

You can add brightness values, subtract the color values of one layer from another even dissolve one image layer into another. These various combinations are known as blend modes, and you'll find the option to apply them in the Layers palette and at other locations around Photoshop. In fact Photoshop provides rather a wide range of blend modes and using them without an understanding of the underlying process can lead to unpredictable results. Look closer at just some of the more useful blend modes and discover how we can put them to use to enhance your images. Take two images, a continuous background, and a cut-out layer with transparent surroundings.

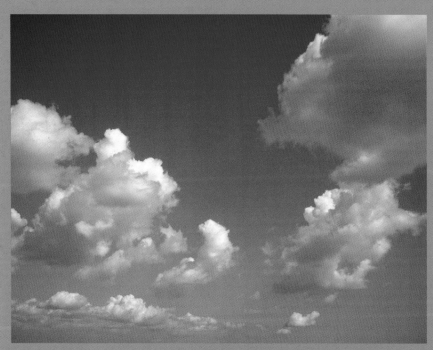

The original background image. This will comprise the Background layer in the blended image.

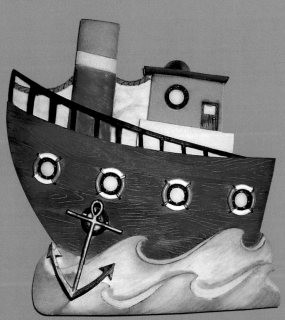

The Image layer. This will be blended with your background shot.

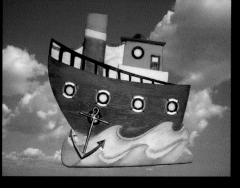

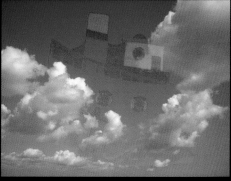

NORMAL
This is the default mode. When a layer is in normal mode and contains opaque pixels, there is no interaction with the background layer. When the slider on the Layers palette is adjusted, the image becomes a proportional mix of the layer and the background image.

COLOR
This one combines the color information in a layer with the image background. It is useful for toning, boosting, or modifying the color in an image without otherwise changing that image.

HUE
This maintains the original brightness and color saturation of the background image, but applies the hue of the layer. It is useful for tinting images based on the colors in the layer.

MULTIPLY
This creates an effect rather like a conventional sandwich of two transparencies. The resulting image is always darker than either of the originals.

SCREEN
Imagine, rather than sandwiching two transparencies together, project each so they overlap—this is the result of using Screen. The result is always lighter than the original images.

OVERLAY, SOFT LIGHT, AND HARD LIGHT
These three modes offer progressively stronger results. The result is much as the same as printing on photographic paper: the base image and then the layer image. Soft Light is equivalent to a short exposure of the layer, Overlay a slightly stronger exposure, and Hard Light the heaviest.

USING BLEND MODES

SO WE'VE SEEN THE MECHANICS—IN A DIGITAL SENSE—OF HOW BLEND MODES ACTUALLY WORK. ITS VERSATILE FEATURES MEAN THAT ITS SELECTION PULL-DOWN MODES CAN BE FOUND THROUGHOUT PHOTOSHOP.

BOTTOM LEFT
This image is faded so badly, applying normal restoration tools would be unsuccessful.

BOTTOM MIDDLE
Multiply Blend mode adds density without otherwise compromising the image.

BOTTOM RIGHT
You may need to repeat the technique. Unlike some filter effects (which should be used sparingly) this is quite acceptable.

What do you do about a photo that is so faded it's beyond reasonable recovery using normal tools? The answer is to use the Multiply blend modes. Multiply makes a sandwich of two images to combine the result. If the images are identical, it builds density and counteracts fading.

TUTORIAL
Building density to improve photos

1 Begin by creating a new layer. From the Layers menu, select New Adjustment Layer>Levels.

2 In the Layers palette, change the Blend mode from Normal to Multiply. The image will become denser.

3 If you need more density, repeat the process— creating another Levels adjustment layer—to achieve a better density. Afterward, you can treat with tools such as Brightness/Contrast.

TUTORIAL
Using blend modes to correct overexposed flash images

1 You can use Multiply to make other, similar adjustments, too. Digital cameras, for the most part have competent flash units. But, at close range, these can give portraits a bleached-out appearance (see below).

2 You can fix this at a stroke using Multiply in blend modes. Simply copy the image background using Layer>Duplicate Layer, and then change the blend mode again to multiply.

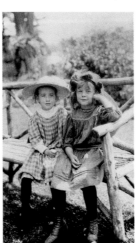

Used close up, the flash has overexposed this portrait.

Multiply's density-building formula corrects this at a stroke.

TUTORIAL
Using blend modes to fix underexposure

Fixing underexposed photos requires a knowledge of Levels. This can be fiddly to get right but with blend mode there is another option.

1 Create a new layer of the underexposed photo and change the blend mode from Normal to Screen. The photo will be lightened but without the harsh look of using Brightness controls.

2 If you haven't totally solved the underexposure problem, create another layer and repeat. Fine-tune the exposure by using the Opacity slider on the Layers palette.

The original underexposed image.

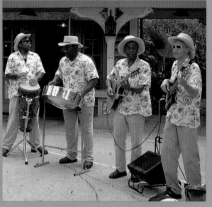

Once you've solved the overexposure problem, use the Opacity slider on the Layers palette to fine-tune.

TUTORIAL
Using blend modes and the Clone tool

Enhancing portraits is often a euphemism for removing blemishes. Using the Clone tool to clone a nearby patch of skin works well to a point, but skin varies so much in tone and texture that a clone of an adjacent patch can be obvious.

1 Modify the Clone tool by changing its blend mode. Use the drop-down menu in the Tool Options bar to change the mode to Lighten.

2 The Lighten mode only affects pixels that are darker than the sampled ones so normal skin tones are left unchanged, but the darker ones of the blemish are altered.

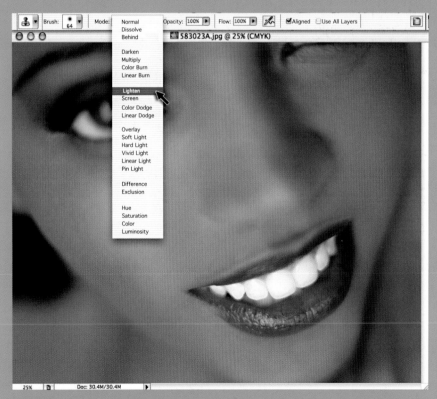

The Lighten mode, applied to the Clone tool, is excellent for removing dark skin blemishes that are difficult to remove otherwise.

06

FILTERS AND SPECIAL EFFECTS

In conventional photography there is a healthy market in after-sales filters, some of which are useful. Polarizers, for example, help cut down reflections and enrich color. Others, such as the deep red and orange filters used to alter sky color in black-and-white photography, are really useful. But some are downright wacky. With names like Spectral Burst, Color Halo, and Star Fantasy, these tend to get used once and then migrate to the bottom of your kit bag never to make contact with a lens again!

Special effects filters used in image-editing applications are the successors to all of these.

The significant difference between traditional filters
and effects, and those of our image-editing application
is that digital effects are applied after an image has
been taken. The trouble with traditional, in-camera
special effects is that they are forever burned into
your images. If you don't like them when your film
is processed there's little—if anything—you can do

FILTER EFFECTS

IT'S EASY TO APPLY A FILTER TO AN IMAGE, BUT THE RESULTS CAN SOMETIMES BE A LITTLE UNPREDICTABLE. BY TAKING TWO DIFFERENT IMAGES AND APPLYING A SELECTION OF FILTERS TO THEM, IT IS EASY TO SEE WHAT EFFECTS YOU CAN ACHIEVE: ONE IS AN ACTION SHOT OF A RUNNER AND THE OTHER A STILL LIFE.

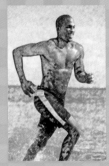
Original

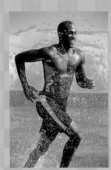
Plastic Wrap

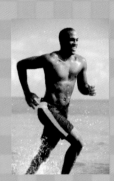
Water Paper

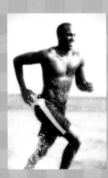
Diffuse Glow

Original

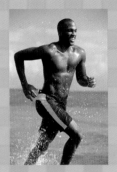
Colored Pencil

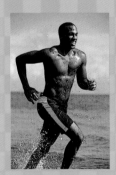
Poster Edges

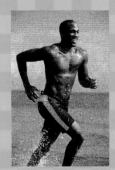
Craquelure

Emboss

Colored Pencil

Graphic Pen

Rough Pastels

Crystallize

Extrude

Graphic Pen

Plastic Wrap

Water Paper

Diffuse Glow

Poster Edges

Craquelure

Emboss

Rough Pastels

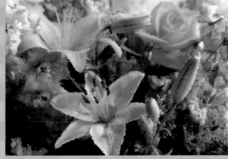

Crystallize

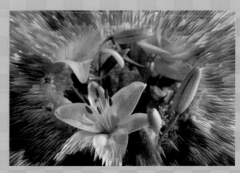

Extrude

MORE FILTER EFFECTS

IF THE RAFT OF PHOTOSHOP FILTERS IS NOT ENOUGH, THERE ARE HUNDREDS, IF NOT THOUSANDS, MORE THAT YOU CAN BUY. MOST IMAGE EDITORS ACCEPT PLUG-IN FILTERS, WHICH CAN BE ADDED TO THE HOST APPLICATION AND APPEAR IN THE FILTERS MENU IN THE SAME WAY AS NATIVE FILTERS.

Plug-ins, as they are usually (if imprecisely) known, vary in quality, effect, and price. You'll find some available as freeware and shareware (that is, either free to use or available for a nominal cost, perhaps $10 or $15). Others are priced commercially either as single filters or packaged together.

Packages, that may include ten or more plug-ins, are rather like music albums. In the same way that an album contains three or four memorable tracks, half a dozen passable ones, and a couple that make you reach for the "skip" button, so filter collections often comprise the good, the bad, and the downright ugly! Neither is price an indication of quality or efficacy, but thankfully, most plug-in vendors offer trials of their filters so your can test their worth before committing your hard-earned money.

As with all filters, moderation is the key. And, as with conventional filters, don't apply a wild or wacky filter for its own sake; have a vision for your image and use the plug-in filter that will best help you realize this.

The Flood dialog has a great number of control-parameter sliders. You can vary them and check the consequences in the Preview panel.

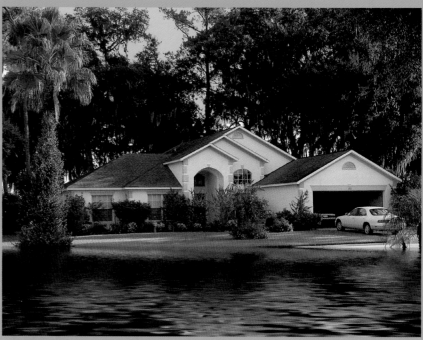

Using default settings Flood gives very realistic flooding/water effects.

All at sea

The Flood filter from Flaming Pear Software is an example of a dramatic plug-in that offers powerful, convincing effects. Its premise is simple: it floods a selected area with water and, through the judicious use of reflections and wave structure, gives the appearance of either flooding or a "real" lake.

Like many plug-in filters, the dialog box for Flood is somewhat unique and unlike those of in-built filters. This one allows the depth, angle, and texture of the water to be varied, and also enables you to make adjustments to the perspective to help deliver the most realistic results.

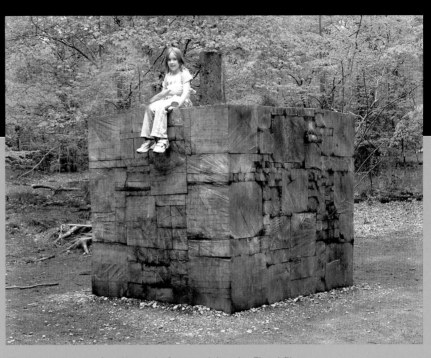

The original water-free image before applying the Flood filter.

TIP

■ **If you want to check out plug-in filter sets, look at Eye Candy and Xenofex by Alien Skin Software. Both are Mac- and PC-compatible, and each collection contains some truly useful effects that you can use time and time again.**

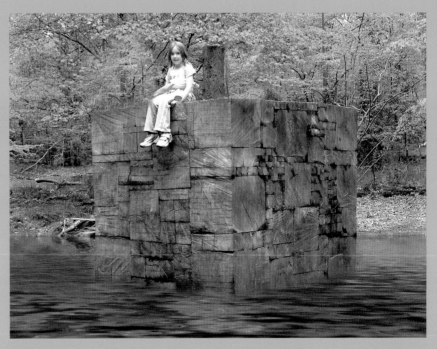

Flood creates very effective water effects. Note how the reflections here authentically reproduce color and light levels from the surrounding landscape.

GETTING SERIOUS WITH COLOR

WHEN WE VISIT EXOTIC DESTINATIONS WE ARE OFTEN DISAPPOINTED THAT OUR PHOTOS DON'T MEASURE UP TO THE BRIGHT, COLORFUL VIEWS WE EXPERIENCED. THANKFULLY, THERE ARE A RANGE OF FEATURES THAT CAN BE USED TO IMPROVE OR ENHANCE YOUR IMAGES.

There are a few ways you can attempt to correct poor color. You could go for the Hue/Saturation command and give the color saturation a boost. But this can often be detrimental. The color increases—no doubt—but you can also introduce degrading digital artefacts as more and more pixels become oversaturated. The result is a mottled, over-processed result particularly visible in blue skies. There must be a better way.

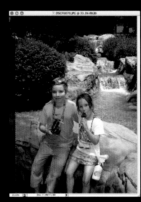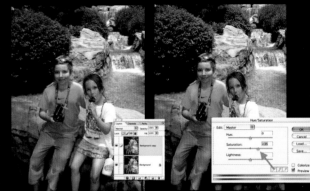

Original image is okay, but the colors aren't too punchy.

A duplicate layer in Normal mode doesn't alter the image.

Boosting Saturation adds color but also adds chromatic (color) noise.

TUTORIAL
Using Unsharp Coloration

Of course, in the digital world, where almost anything is possible you can use a technique dubbed Unsharp Coloration to enhance color with blurred overlays.

1 Perform any edits and manipulations you require on your original image first, perhaps using the Clone tool to tidy up the landscape or Crop tool to eliminate any unwanted detail.

2 Select Layer>Duplicate Layer. This produces an identical copy of our background image in a layer. Use this layer to provide enhanced color.

3 Use the Hue/Saturation command (Image>Adjustments>Hue/Saturation) to increase the saturation. Don't be afraid to increase this more than you'd want, you can refine the amount later.

4 Apply a Gaussian Blur (Filter>Blur>Gaussian Blur) to the layer. A modest amount (around three pixels) is usually sufficient. This will blur away any artefacts rendering colored areas more continuous, but at the cost of the sharpness of the image.

5 For your finished result, change the blend mode of the layer from Normal to Color. This will combine only the color of the image layer with the sharp background. The result? Enriched color with the sharpness of the original but no artefacts. You can vary the amount of color by using the opacity slider on the Layers palette.

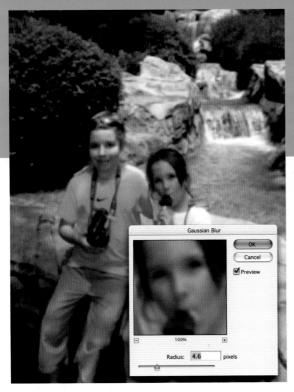

The Gaussian Blur blurs away noise on artifacts.

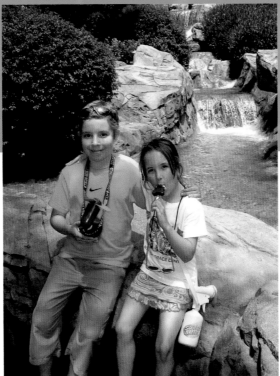

Combining a blurred color layer and sharp background gives a sharp, colorful result.

TUTORIAL
Adjusting the "sunburn effect"

Enriching color using Unsharp Coloration can often give skin tones a lift, with pale skin colors becoming more red. But, as here, often skin color can become unnaturally red.

1 To alter the saturation of the reds in the image, use Hue/Saturation (Image>Adjustments> Hue/Saturation). You can affect just the skin areas by selecting them beforehand.

2 In the Hue/Saturation dialog box use the pull-down menu to select reds and nudge the saturation down (to the left) until colors become more natural.

Selectively desaturating reds in a portrait gives more natural skin tones.

BLUR FILTERS

BLUR FILTERS ARE ONE OF THE KEY FILTER SETS IN DIGITAL PHOTOGRAPHY. IT MIGHT SEEM ODD THAT ONE MIGHT ACTUALLY WANT TO BLUR AN IMAGE WHEN PHOTOGRAPHERS WORK SO HARD TO GET PIN-SHARP PICTURES, BUT BLURRING CAN BE VERY EFFECTIVE.

There are a number of reasons why you might want to introduce blurring into an image. First, selective blurring of parts of an image gives added emphasis to the subject. By carefully adding blurring to a subject's surroundings (and varying that softness with distance into the scene) we can simulate depth of field.

Blurring can also add a sense of motion. Motion Blur filter applied to a vehicle, for example, can give an added sense of speed, even if that vehicle was originally stationary. And Radial Blur filters can serve either to give that sense of motion—this time toward or away from the camera—or focus attention on the centrally placed subject.

TUTORIAL
Digital depth of field

Emphasizing depth of field has long been used to draw attention from a subject's surroundings to the subject itself. Digital cameras make this technique even more relevant. Apart from some of the top-end digital cameras, most models are capable of keeping virtually the whole of a scene in focus, from the far distance through to just a couple of feet from the camera. This is ideal for getting pin-sharp photos, but does require some remedial action on your part to add depth of field.

ABOVE
Sharp from foreground to infinity—a characteristic of almost every digital compact camera.

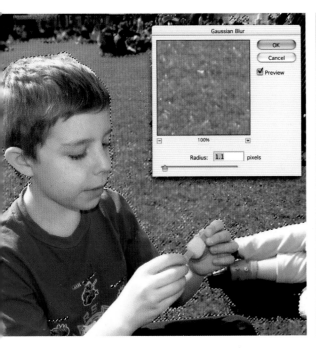

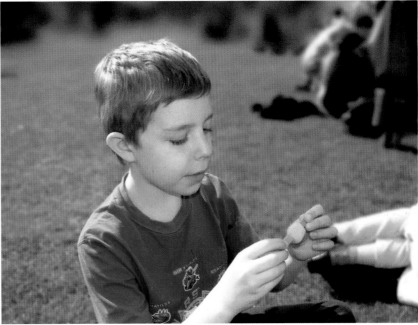

1 In the image, above left, everything from the boy's body through to the background landscape (infinity) is in sharp focus. If a professional camera with a wide aperture had been used, the ground in front and behind would be blurred, and the background landscape very unsharp.

2 To increase the depth of field, first select the boy using the Magnetic Lasso. Invert the selection (Select>Invert) so that all the surroundings are selected. You can now apply a modest blur to all these areas using Filter> Blur>Gaussian Blur. Begin by using a blur amount of just one pixel.

3 Next, select increasingly distant parts of the scene. Each time apply the Gaussian Blur, but with a radius of two pixels on each occasion. You'll see that the background gets progressively more blurred and less obtrusive.

4 Finally, you get an image in which the subject is sharply defined but the background gets steadily more blurred with distance—exactly the same as you would expect had you used a wide aperture lens.

ABOVE LEFT
Select progressively more distant parts of the scene and blur.

ABOVE RIGHT
To achieve shallow depth of field in-camera requires specialized wide-aperture portrait lenses.

CREATIVE BLURRING

MOTION AND RADIAL BLUR FILTERS ARE BEST DESCRIBED AS CREATIVE BLUR FILTERS. THEY
CAN BE USED TO PRODUCE DRAMATIC, ATTENTION-GRABBING IMAGES OR DECEPTIVE EFFECTS.

Radial blurs

BELOW LEFT AND MIDDLE
A simple zoom Radial Blur produces an image that your eyes have difficulty settling on. Great for attention-grabbing, but less satisfactory for a framed print.

BELOW RIGHT
Applying the Zoom Blur only to the surroundings gives a more settled image that still conveys motion without dazzling your eyes.

The Radial Blur filter has two flavors: Zoom and Spin. Applying the Zoom blur gives images the appearance of, literally, "zooming" into the subject and is effective on transforming stationary objects into moving ones. The result can be very powerful, if unsettling on the eyes.

For a better impression of speed that your eyes won't struggle to view, select the central area of the image using the Lasso tool. Set a reasonable amount of feathering to soften the edge of the selection. Apply the Zoom just to the surroundings by inverting the selection (Select>Inverse). You'll get a better impression of speed and your eyes won't struggle to view it.

The alternative filter, Spin, offers you equally dizzying effects. In practice, you can use this to make wheels appear as if they are spinning even though they were stationary when photographed.

LEFT
This is the wheel of a parked car.

RIGHT
Radial Blur has been applied to the wheel and Motion Blur to the grass.

Motion blurs

The spin Radial Blur does a good job of making a static object appear to be in motion. But you can enhance the effect further by making the vehicle itself, or perhaps the background, also appear to be in relative motion. That's where the Motion Blur filter comes in. Apply the Motion Blur to an image or selection and all points in that selection are dragged linearly at a predetermined angle.

Apply the Radial and Motion Blur filters to this car to give the impression of it moving.

First select each of the wheels and apply the Radial Blur (in spin mode) as described above. Next, select the surroundings of the car and apply the Motion Blur to this. The result is remarkably realistic. The car is cruising along Main Street—and without a driver, too!

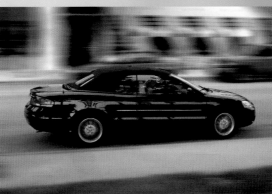

LEFT
A parked car.

RIGHT
Applying Motion Blur (and radial blur to the wheels) gives the impression that you've panned the camera as it moved past.

GOOD, BETTER, BEST

The Radial Blur filter has three quality options. Creating a radial blur effect on an image requires a lot of processing power so it might take time. It's a good idea to test the effect using the lowest-quality setting. This takes just a few seconds, and is good for assessing the amount of blurring applied and the position. Once you're happy, switch to Best quality for the final application.

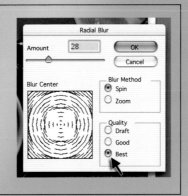

07

IDEAS AND INSPIRATION

With the key concepts and techniques of the digital darkroom mastered, it's time to put them all into practice and discover just how easy it is create great images.

TAKE THE ART WORLD BY STORM

It's taken some time, but, at long last, photography shares the status and collectibility formerly only enjoyed by fine art. But, as if to assert the significance and esteem in which traditional artworks are held, many photographers use digital imaging to convert their finest pictures into faux paintings. The tools to create them are all included in your image-editing

GET A MOVE ON

**Many digital cameras include a movie mode that
records digital video clips onto the same memory
cards that you use for your still images. Gimmick or
asset? It may not directly replace your digital video
camera but your digital stills camera can make a
great job of recording events and locations. And**

DARKROOM PROCESSES

SINCE THE EARLIEST DAYS OF PHOTOGRAPHY, COUNTLESS PROCESSES AND TECHNIQUES HAVE ACHIEVED POPULARITY AND BECOME PART OF EVERYDAY USAGE. OTHERS—FOR ALL KINDS OF REASONS—HAVE HAD A MORE CHEQUERED HISTORY. WITH DIGITAL PROCESSES THERE IS ALL THE POSSIBILITY, WITHOUT THE ASSOCIATED CONCERNS.

TUTORIAL
Recreating the gum dichromate look

The gum dichromate process was popular at the turn of the twentieth century in the production of subtly colored images. In those days, color was quite rare in photography.

Artistic photographers could produce multicolored images by successive applications. We can do the same with more control and, unlike our ancestors, are not necessarily limited to still-life subjects.

1 Begin with a Grayscale image. This needn't be a black-and-white image. A color one converted to grayscale using Image>Mode>Grayscale is fine. Convert the image back to a color mode one (it will still appear as black and white) using Image>Mode>RGB. This will enable us to add color.

2 Use Select>Color Range to select the gray midtones. Set the Fuzziness slider to 75 to select all the midtone grays. Now use a paintbrush and paint over the selected regions. You can use any color but for a more faithful gum dichromate stick with more muted pastels.

3 Repeat, in turn, for the highlights and shadow areas, applying an appropriate color for each. All the gray tones should be replaced with one of three colors. The image should look great, but for that extra bit of atmosphere, consider adding a fine amount of grain. This not only simulates the coarse nature of early photographic grain but also adds a coherence to the colored areas.

Simple industrial images work best with special effect processes such as Gum Dichromate.

Here the mid-tone grays have been selected and colored.

With each part of the image (light, dark, and mid-tone) colored, we get this characteristic polychromatic result.

ADDING WORDS

MANY CREATIVE PROJECTS BENEFIT FROM USING IMAGES AND WORDS TOGETHER. YOU CAN BURN CAPTIONS INTO IMAGES, ADD TITLES TO PHOTOS, OR INCORPORATE IMAGES INTO OTHERWISE PLAIN NEWSLETTERS OR DESKTOP PUBLISHING.

LEFT AND RIGHT
Layer styles. A wide range of layer styles are offered in Photoshop, as shown here.

There will be occasions when it will be appropriate—or even necessary—to add text to an image. You might, for example, want to add a caption to an image. Or you may be using an image as part of a graphic, where words comprise an essential part of the project. Desktop publishing and newsletter-creation often demands text—image combinations, too.

The mechanics of applying text is different to other image elements. When you add text to an image it's applied in its own layer. Depending on your Photoshop version you can apply any font, any size, and even twist and warp the text. Text is laid as a vector shape rather than a bitmapped image which means you can change the size of the text, or select a new font without pixellation or other potential artificing.

TUTORIAL
Applying Layer Styles to text

1 When text is applied to an image it appears in its own layer. This gives us the opportunity to manipulate the way in which the contents of this layer, that is the text itself, interacts with the image background.

2 Select Layer>Layer Style>Drop Shadow to open Layer Styles. In Drop Shadow mode you can set the shadow angle along with the spread, density, color, and other parameters until you get the required result. An approximation of this is shown by the graphic to the right of the dialog.

3 You can also apply other Layer effects to the text. Select another from the list to the left of the dialog and modify the corresponding parameters. Here the text has been given an Inner Shadow in addition to the drop shadow.

3 Finally, a Stroke has been applied. This applies a fine line (measured in pixels) around the edges of the text. Using a bold color (as here) or a contrasting one (black for white text, for example) helps emphasize text.

Another example of layer styles offered by Photoshop that you can incorporate into your designs.

TUTORIAL
Creating Text Masks

1 You can create text of any color but by employing text masks you can infill text using a gradient or second image. To create a Text Mask create a new layer over an image background by selecting Layer>New>Layer. Fill this with a color. Choose the Text Mask tool from the tool bar.

2 Type your text with chosen font and size. Type Masks generally work best with bold fonts. The text will be shown as a selection.

3 Press the delete key. This will delete the area in the selection and reveal the image beneath.

MODERATION, MODERATION
Applying layer effects to text layers can produce wacky results. Moderation is the key to success. Too many colors and effects gives gaudy results that will irritate rather than impress any recipient of your artwork.

THE ART OF DIGITAL IMAGING

PHOTOSHOP FEATURES A WIDE SELECTION OF ARTISTIC FILTERS, WHICH SUGGEST THAT YOU CAN IMPART AN ARTISTIC EFFECT TO YOUR IMAGES, BUT CREATING A MASTERPIECE REQUIRES UNDERSTANDING OF THE UNDERLYING PROCESSES, AND AN EMPATHETIC TREATMENT.

TUTORIAL
Applying text to an image

Many digital-imaging professionals eschew blatant artistic interpretations, and instead aim to produce something original.

Creating an artwork involves consideration and technique in equal measure. What treatment would suit your image? How will you implement that technique? And how can you best achieve your goal?

1 This view is of the bayside harbor lighthouse at Orlando's Sea World. Despite the semi-tropical location, the scene evokes the colors and ambience of New England. A good interpretation of this scene would, perhaps, be watercolor, but let's try using the Rough Pastels filter.

2 Curiously for this interpretation, begin by enriching the color in the scene using the Hue/Saturation dialog (Image>Adjustments>Hue/Saturation). The saturation has been increased by 20 percent, but the contrast too has been increased, by about 10 percent. The result is rather harsh, and the coloration is verging on the unnatural.

3 Apply a modest amount of noise to the image (Filter>Noise>Add Noise). In doing so, you rein in some of the harshness from the image and also reduce any artifacts that appear when saturation alone is increased.

4 Select the Rough Pastels filter and apply using a Canvas texture and broad, diagonal strokes. Stroke length and other settings will depend upon the kind of image, and its scale. Use the Preview thumbnail to assess any changes before you apply them.

5 Add a new layer to the image (Layer>New Layer) and fill it with white paint using the Bucket (Flood) tool. Apply a layer mask to the image by clicking on the small icon at the base of the Layers palette. With a rough-textured paintbrush, paint over the mask with black paint to reveal the image and give a rough, pastel-marked appearance. If you make a mistake, change the paint color to white and remove the mask.

6 The resulting image looks as if it was created with natural media. The fidelity of the original image remains but the texture is that of pastel on canvas. To give the result a more washed-out look—perhaps closer to natural pastel—reduce the saturation (for example, here it's been set to -60).

A straight snapshot forms the basis of our artwork.

For strong tone and color, saturation and contrast has been boosted.

Noise helps break up the photographic look of the image.

Rough Pastels is a rather brutal filter but great for adding an art texture.

A rough vignette gives a painterly look.

The finished image looks like a pastel sketch.

Reducing Saturation (Image>Adjustments>Hue/ Saturation) to 60 percent gives a softer, washed-out look.

ART WITHOUT THE ARTISANS

WE'RE CONSTANTLY TOLD THAT DIGITAL IMAGING MAKES GREAT IMAGES EASY. AND, GUESS WHAT? THAT'S RIGHT! WHEN IT COMES TO CHANGING YOUR IMAGE INTO A WORK OF ART, THERE ARE WAYS OF GETTING IMPRESSIVE FINE-ART RESULTS VERY SIMPLY.

TUTORIAL
Emulating the Victorian woodcut

Take a look though an illustrated copy of a Charles Dickens novel and you'll find woodcut illustrations that capture the essence of Victorian England. Using India Ink—a special effect filter from Flaming Pear—you can give any image the woodcut treatment.

1 The original photograph of an English post office.

2 Select the India Ink filter to open a dialog box with an enticingly large range of controls. Like most filters, the default settings are often the best,

but don't be afraid to play with them. Push the sliders to their extreme positions. You are unlikely to ever use the filter at these settings but doing so enables you to see what they look like.

3 With just the default settings you get an image with an effective woodcut-look.

BELOW
Soft, muted colors characterize this English cottage.

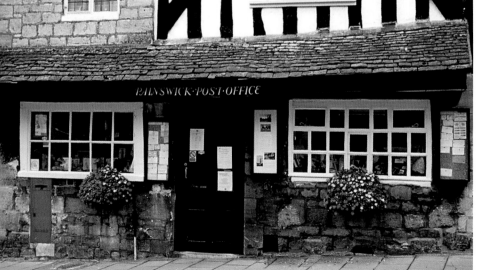

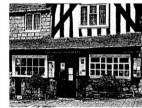

Like Flood, India Ink features a bewildering range of controls.

Using the Default settings gives great results.

Choose alternative settings for more unusual results.

There's no right or wrong with these—if you like it, it's okay!

The original, full-color image of a vintage car.

4 Using alternate settings, introduce color to the image. The colors are set automatically so you have little control, but you can preview the results.

5 The colors are nothing like those you'd expect to see in a real scene, but does it matter? Somehow, they work. And, strangely enough, some of the more expensive copies of Victorian novels would feature hand-colored woodcut illustrations just as absurdly colored as these.

Application of the Graphic Pen filter.

TUTORIAL
Using the Graphic Pen effect

1 You don't need plug-in filters to get strong, graphic effects. The Graphic Pen filter (Filter>Sketch> Graphic Pen) gives this vintage Chevy a hand-drawn look.

2 You can produce a color image by using a variation of the Unsharp Coloration technique. Create a duplicate layer from the background, and then apply the Graphic Pen filter to the background. Change the Blend Mode to Color, et voilà! The key to original effects is experimentation. You'll create some howlers on the way, but that's how you learn.

The Graphic Pen filter combined with the original background.

INFRARED FILM EFFECTS

ONCE IN A WHILE INFRARED PHOTOGRAPHY IS "REDISCOVERED". FOR THAT PERIOD ALL MANNER OF SUBJECTS ARE GIVEN THE INFRARED TREATMENT. BUT MANY—LANDSCAPE PHOTOGRAPHERS, IN PARTICULAR—HAVE ENJOYED GREAT SUCCESS USING INFRARED FILM TO CREATE ENDURING, BEAUTIFUL IMAGES.

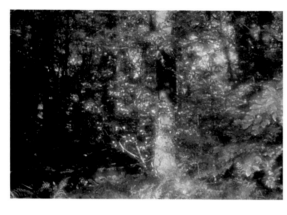
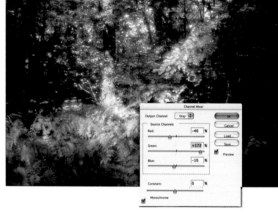

LEFT
Foliage images deliver the best results when creating infrared results. This color image has a luminous quality that will be enhanced by the treatment.

ABOVE RIGHT
The Channel Mixer enables you to alter the balance between the color channels in an image, changing their significance in the final image.

FACING OPPOSITE, LEFT
The changes to the color channel have produced an approximate infrared effect but it still lacks the ethereal quality.

FACING OPPOSITE, RIGHT
Soft focus has given the image the required ghostly feel that characterizes infrared images.

There are landscape photographers who have built (or at least consolidated) their preeminent position by using infrared film and have, over the years, shown what this remarkable emulsion is capable of: ethereal, almost-white foliage and dark, forbidding skies.

Recreating the effect is a two-stage process. First, you need to emulate the high infrared reflectance of foliage, then use the soft-focus process used earlier to give the image its "otherworldly" look. Note that infrared film emulsions don't intrinsically deliver soft-focused results. The softening occurs because lenses are not designed to give their best in these wavelengths so optical quality deteriorates slightly.

TUTORIAL
Creating infrared effects on an image

1 Take the image and open the Channel Mixer (Image>Adjustments>Channel Mixer). Push the Green channel to maximum to brighten the greens, and reduce the Blue and Red for a further boost.

2 The net result is an image in which, tonally, the foliage dominates. And by reducing the blue and red, those parts of the image where these colors predominate become darker.

3 The image has the curious tonality of infrared film but without its unique qualities. Give it a soft-focus treatment by creating a duplicate layer and using Gaussian Blur filter (Filter>Blur>Gaussian Blur) on it. Because the foliage is so prominent, the blurring tends to be, too.

COLOR INFRARED

Color infrared has suffered somewhat in the wake of digital photography. It was cherished by many photographers because of the absurd, often unpredictable results it gave. Rather than the luminescence of monochrome infrared, the color emulsion delivers false color effects. But digitally it is possible to introduce all manner of false coloration by simple movement of the Hue/Saturation slider. Color infrared has had its day.

Color infrared effects are so simple to achieve digitally that the technique has lost its novelty value and no longer has mass appeal.

CREATING FINE ART IMAGES

DUOTONES ARE IMAGES THAT CONTAIN TWO COLORS, ONE OF WHICH IS NORMALLY BLACK. THEY HAVE BEEN USED TO PRODUCE BETTER RESULTS FOR PRINTED IMAGES, PARTICULARLY IN FINE-ART BOOKS, AND CAN GIVE SOME HIGH-CONTRAST IMAGES A PLEASINGLY SUBTLE RENDITION.

TUTORIAL
Creating a duotone effect

1 First convert your image to Duotone mode (Image>Mode>Duotone). If you are starting with a color image you'll need to convert the image to Grayscale first (Image>Mode>Grayscale). You can only create a Duotone from a monochrome image.

2 In the dialog box, select Duotone from the drop-down menu. Select a secondary color and adjust the curves by clicking on the boxes for each color. Sounds baffling? At first, but Photoshop has given you some pre-set duotone settings which you can load by clicking on the button in the dialog box.

3 As you select the pre-sets, pay attention to the shadow areas. What begins as a solid black will become a better grade, with more texture and form. Take a look at the swimsuit in the pair of "before" and "after" images, below. This is one of the key strengths of the duotone technique.

4 Things get better when you print your image. Print "before" and "after" images to see how subtle the effect is.

The original image.

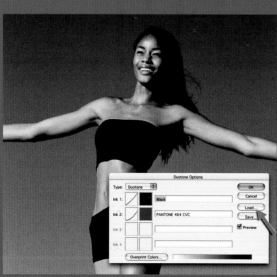

Creating a duotone effect by first making the image Grayscale and then selecting Image>Mode>Duotone.

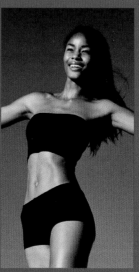
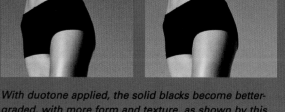

With duotone applied, the solid blacks become better-graded, with more form and texture, as shown by this pair of "before" and "after" shots.

TUTORIAL
Reducing contrast

1 Bright sunlit shots like this can become dominated by bright highlights and very dark shadows. When printed, the results can be disappointing and most corrective measures don't achieve the required effect. Converting to a duotone can help reduce contrast without compromising the image.

2 Create a duotone by selecting Image>Mode> Grayscale and then Image>Mode>Duotone (you can't select Duotone directly from a color image). Click on the Curves thumbnail to open the Duotones Curves dialog and modify the shape as shown here.

3 The resulting image has lower contrast but is not "flat" in the way that some low-contrast images are (you may need to adjust your curve according to the content of the image).

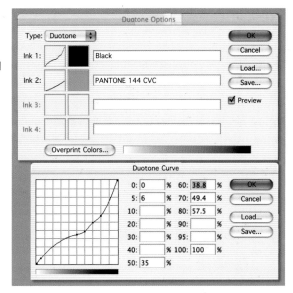

LEFT
Screengrab showing the dialog box you need to access the Duotone Curve which enables you to alter the contrast in your image.

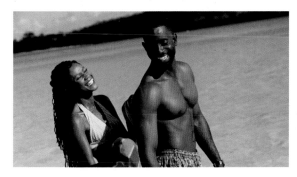

The original color image containing bright highlights and dark shadows, which can be a little unflattering.

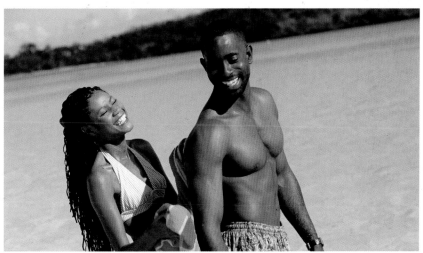

The final image, with the Dutotone effect applied. It makes for a much more pleasing image, particularly when printed.

FUN, FUN, FUN

WHAT IS IT ABOUT PHOTOGRAPHY THAT MAKES IT SO COMPELLING? IS IT BECAUSE IT HELPS US RECORD OUR MEMORIES? OR DOES IT SATISFY OUR CREATIVE INSTINCT? IT IS EASY TO LOSE SIGHT OF AN IMPORTANT ASPECT—IT'S FUN!

ABOVE AND RIGHT
There's something about photo-tapestries that draws you in to explore the constituent thumbnails; screw up your eyes to see the original image.

Photo-tapestry heaven

There's more than one name for this technique but the result is the same: a large image that's produced from a large number of tiny thumbnail images. You've probably seen these used by the advertising industry for images that draw you in closer. You'll also find examples at your local art and poster store, but the effect can be equally effective using your own portraits and landscapes.

ArcSoft's PhotoMontage is a stand-alone application designed to produce photo-tapestries that comes with all you need, including extensive galleries of micro images to use as the component thumbnails. Production is simple, and your first tapestry takes just minutes to produce. All you need do is specify the size of image that you want to create, the number of thumbnail images (the more you use, the better the definition in the final image) and point the program at a directory of thumbnails.

As an alternative to using the stock thumbnails, PhotoMontage can grab images from your photo collection or still images from a digital movie to create a tapestry image with your very own personalized thumbnails.

A photo-tapestry is also a great way of creating large, poster-sized prints without the resolution problems of enlarging standard images. The more thumbnails you include the larger the resultant image can be.

Caricatures

We've spent most of our time learning how to make good photos into great ones. But now it's time to break that convention and start producing images that delight in being wild and wacky. PowerGoo is a brilliant stand-alone application designed to turn everyday (and perhaps rather dull) portraits into something more spectacular. With just a few manipulations of the mouse, your subject turns into a humorous caricature. With a few more clicks, you can add accoutrements such as glasses, hats, and even beards. PowerGoo is certainly not a product to use if you are precious about your photography.

SCRAPBOOK TIME
If you'd like to make photo scrapbooks or conventional albums, photo-tapestry or caricature images are ideal for title pages or to inject humor into your productions. Or, if you're looking for some neat imagery for the cover of a CD- or DVD-based photo collection, either could be the ideal (and novel) solution.

BELOW LEFT AND RIGHT
PowerGoo's innovative interface makes it simple to add humorous features to your chosen face. It can also produce wacky portraits from the most conventional originals.

MOVIES FROM YOUR DIGITAL STILLS CAMERA

THE DIVIDE BETWEEN STILL AND VIDEO CAMERAS IS BEING PROGRESSIVELY ERODED IN THE DIGITAL WORLD. DIGITAL VIDEO CAMERAS ARE CAPABLE OF TAKING GREAT STILL IMAGES AND DIGITAL STILLS CAMERAS OFTEN HAVE A MOVIE MODE. A MARKETING PLOY THAT IS ACTUALLY USEFUL.

The still image mode of digital movie cameras is no real replacement for a dedicated stills camera. Movie cameras don't have sufficient control to satisfy the needs of a stills photographer, and the method of image creation is different. But for snaps or digital images for use on a website they are adequate.

The movie mode of digital stills cameras is more interesting. While sometimes offering very low resolution, an increasing number now offer VGA resolution—640 x 480 pixels—which is sufficient to deliver good results (certainly on a par with VHS video) on conventional 4:3-format television screens. The quality isn't up to that of DV (digital video), but just think: you can get good-quality movies from the same camera that you use to take great still images!

BELOW
VideoImpression features titles, fades, and effects that are easily combined with your own video clips.

Editing your blockbuster

Following a trend started by Fujifilm with their M603 model, some cameras now permit movie clips to be edited in-camera, but generally, you'll need some extra software to edit those clips into a movie. A good choice is VideoImpression from ArcSoft. In fact, this application (available for PC or Mac) is included with many digital cameras.

By stripping away much of the complexity inherent in many video-editing applications, VideoImpression uses simple drag-and-drop techniques to assemble video clips and a similar approach to adding special effects. To produce a professional-looking transition (one scene to the next) you simply drag a suitable effect (such as a fade or wipe) icon to the space between adjacent clips. You'll be watching your first movie masterpiece in just a few minutes!

MOVIES FROM STILL PHOTOS

Even if you don't have a movie mode on your camera you can still create movies from your still images. Applications such as Apple's iMovie 3 enable individual images to be assembled into a movie. Rather than a simple slideshow, your photos take on a dynamic appearance. Each photo can be randomly scanned and zoomed over for intriguing effects rather like those you may see in documentary films and music videos made popular by Ken Burns. You can even choose music to accompany your production.

LEFT
Moody and compelling movies can be created by the careful selection of still images and compilations using applications such as iMovie.

08

OUTPUT OPTIONS

Now you've the tools and skills to create visual masterpieces, how do we share them? Back in the days of the conventional darkroom the options were limited. We could produce a print to adorn our walls or album or maybe a transparency to, literally, illuminate a magic lantern show.

Today, there are many more options. The traditional methods are still available, but now we can also distribute our images via CD, DVD, and over the Web.

particularly extensive—is almost obligatory as a

means of backing up your collection, but it's also a

way of distributing images so that others can enjoy

OUTPUT OPTIONS

SO, HOW DO YOU GO ABOUT CREATING A PERMANENT RECORD OF YOUR MASTERPIECE? IN THIS FINAL CHAPTER, WE LOOK AT HOW TO SET A PRINTER TO PRINT, CREATING AND CHOOSING PROFILES AND PREVIEWS, WHICH PAPERS AND INKS TO USE, AND OPTIONS FOR NON-PRINTING OUTPUT

Papers and inks

If you are dazzled by the array of photo paper, glossy paper, photo-realistic paper, and photocard on offer, you are right to be. Ink-jet paper is not simply a shiny version of ordinary paper, it is a complex set of layers, designed to give you a print that is as close as possible to a real photograph.

The inks used in ink-jet printers are special as well. They come in two main types: dyes, which are a solution of color in a solvent, and pigments, which are tiny flakes of color in a solution. The difference is not so much how they work, but rather the properties of the individual dye or pigment.

How they work together

Most manufacturers make their own inks and papers because the way the two work together can be crucial to the quality of the print. A paper has to be able to accept a certain droplet size that is guaranteed not to spread too little (which means less visible dots) or too much (which produces a smeared look).

The paper and ink have to have the right chemical combination, so that the paper doesn't cause the ink to fade, and the ink doesn't cause the paper to rot. If these things do happen, they happen very slowly. The paper and ink have to work together in terms of the solvent's ability to pass through the top coat of the paper without stippling or banding.

It is possible to use a paper from a different manufacturer with a given printer-and-ink combination, but you never know whether it will work, or whether you have just made a costly mistake—unless, of course, the manufacturer specifies that the paper is acceptable.

Other brands of ink

While you can buy inks made by other manufacturers, it is not worth the risk unless the inks come with a specific color profile when used with the printer. Different inks may also use different solvents to those used by the printer manufacturer. In some cases, this can cause long-term problems with nozzle blocking, or it may simply result in slightly inaccurate colors. Neither outcome is really desirable.

CHANGING PRINTER SETTINGS
Different papers require some of the printer settings to change. This is to optimize the amount of ink for the paper. If a paper is not of the highest quality, it probably has a less bright-white base, and thus should consume less ink during the printing process, or the results will be too dark.

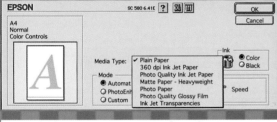

EPSON SC 580 6.41E [?] [⊞] [▥] [OK] [Cancel]

A4
Normal
Color Controls

[A]

Media Type:
- ✓ Plain Paper
- 360 dpi Ink Jet Paper
- Photo Quality Ink Jet Paper
- Matte Paper - Heavyweight
- Photo Paper
- Photo Quality Glossy Film
- Ink Jet Transparencies

Ink
- ● Color
- ○ Black

Mode
- ● Automat
- ○ PhotoEnh
- ○ Custom

Speed

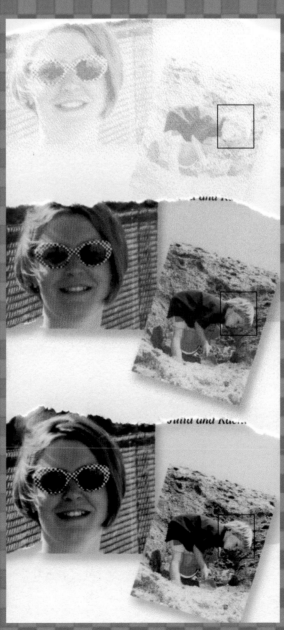

ECONOMY

NORMAL

FINE

TOP LEFT
It is important to select the correct paper type from the settings in the printer driver. If the precise paper in use is not displayed, try the nearest equivalent.

ABOVE AND RIGHT
Choosing incorrect printer settings can result in images that are pale, blurred, or fuzzy. Similarly, incorrect (or inappropriate) inks can be problematic, giving unpredictable results.

ABOVE
Economy modes save ink and time, but at a cost in quality. Normal mode is good for most day-to-day work. Reserve Fine or Best quality for your best work.

PROFILES AND PREVIEWS

AS DIGITAL IMAGING TECHNOLOGY HAS MATURED, FEWER MANUFACTURERS ARE CLAIMING WYSIWYG (WHAT YOU SEE IS WHAT YOU GET) PREVIEWS. THIS IS BECAUSE THEY HAVE STARTED TO ACKNOWLEDGE THE INACCURACY OF COLOR MANAGEMENT.

ABOVE
Attaining accurate color management is essential for color fidelity. With different profiles, a single image can be presented quite differently on different media.

Color management

Color management is the ability to ensure your colors are true from when you capture the digital image until you output it. It is about knowing two things: how your monitor represents the color data in the digital image file, and how the output medium represents the color data of the digital image file.

Photoshop is a professional tool, and its aim is to create accurate reproduction of colors. To this end, it incorporates a system of profiles and previews.

Profiles

Profiles are tables of data which tell the computer how to interpret the color data in a digital image for the purpose of displaying it—either on-screen, on ink-jet paper, on photographic output, or when printed in CMYK. Each output method interprets color in a different way and, unless the right profiles are set for the right devices, your output may not look as it did on-screen. This principle obviously applies to setting up your screen, too.

Previews

If you have set up your profiles properly, then the Proof Set up and Proof Colors sections of the Photoshop View menu come into their own.

The key to color management is not trying to match your output to the image on the screen. Rather, it is trying to make your screen display match the colors as they appear on the output. This is a subtle, but critical, difference. Monitors can display colors that printed media cannot, which means it is important that you set the right preview.

Gamut warning

Some output media cannot produce certain colors. Thus, it is important to know that when you perform manipulations that what you require is possible for the output media (whether it is "in gamut" or not). The Gamut Warning setting enables you to see whether any colors are "overdone". It displays a bright color in all the pixels where the output medium will not be able to deliver the required colors.

Email output and printing

There are many reasons for sending images by email, and the form and size you choose for an image is dependent on your final application. Sometimes you may not know what this final application will be, so the only solution is to go for the highest-possible quality and the biggest physical size, while balancing this with the time it will take to deliver the email. Broadband, which is a much faster connection, makes this an easier decision. Regardless, you must decide between quality, size, and speed.

A good starting point for printing an image is to save it at 300ppi at 6x4in (15x10cm). This requires an image resolution of 1,800x1,200 pixels. For a 1,800x1,200 pixel image (with a file size of 6.18Mb as a Photoshop PSD), you will create a JPEG file of about 400Kb for a file saved through the Save for Web option in Photoshop, or 200Kb if you use a small piece of alternative software—BoxTop's ProJpeg, for example. Unless you are asked to send a bigger image, you will save a lot of time by doing the image size and compression work in advance.

Web output

There are a number of formats to choose. But what about preparing galleries for your own website? It's best to leave decisions about image-use to the visitor. This means creating three different image files:

- A thumbnail: an image small enough to show what's in the image (1½x1in at 72ppi, or 108x72 pixels).
- A large screen-resolution view, about 720x480 pixels.
- A full-size printable download.

TUTORIAL
Resizing images for the Web

Resizing images for the Web invariably involves reducing them in size. This is simple, but you need to ensure that each is conducted in order.

1 Save your image as a JPEG. This is the format most commonly used for Web images and allows the greatest degree of compression. Select File>Save As and use the pull-down menu to select JPEG.

2 Re-size the image. Choose Image>Image Size. Enter your chosen dimensions for the image (you can use pixels, inches, or centimeters). Enter a screen resolution (normally 72dpi).

3 Save the image with a new file name. This ensures that the newly saved image will be a JPEG format at the new size and your original image is retained at the original, larger size.

TOP
Using the pull-down menu to save the image as a JPEG.

MIDDLE
Resizing the image to the required dimensions.

BOTTOM
The final, resized image.

PHOTOGRAPHY AND THE WEB

PRINTING YOUR PHOTOS REMAINS THE PRINCIPAL METHOD OF ENJOYING YOUR WORK BUT, OF COURSE, IT'S NOT THE ONLY MEDIUM. THE NATURE OF DIGITAL IMAGES MAKES THEM IDEALLY SUITED TO DISTRIBUTION BY OTHER DIGITAL MEANS.

Images for email

Writing your images to CD for replay on another computer (or DVD player, see panel opposite) is one way of sharing images. But this physical dissemination lacks the immediacy possible by using the Web. By sending your images as email attachments, you can share them instantly with as few or as many people as you wish.

The main consideration when choosing images to send by email is their size. The images that come out of your digital camera are usually compressed in JPEG format, making them small enough to store on camera memory cards. But once manipulated, you'll probably find the file size is larger, particularly if you use a non-compressive format such as TIFF. To send images by email you must ensure that, in file-size terms, they are as small as possible.

TUTORIAL
Compressing images for email

1 Select the images you want to send and, one by one, save them with a new filename (preserving the original files at their original size and quality), and as a JPEG file. Use the Quality slider to produce a small file size. The more you compress (moving the slider to the left), the smaller the file will be.

2 Once your image is compressed, check the file size—200Kb is fine—and the image-quality is okay. Compressing images can reduce quality.

3 Collect your images and email them. Don't send too many. Even if you have a Broadband connection, don't assume everyone has. You don't want someone's mailbox locked forever while your photos download!

RIGHT
Move the slider to the left to reduce the file size, but watch that quality isn't unduly compromised.

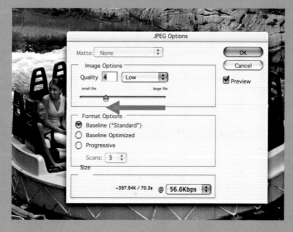

LEFT
Use the attachments button to append your images to an email.

BURN, BABY, BURN

While sending pictures by email is fun, and creating Web photo galleries is simple, creating CDs and DVDs of your images is a great way to produce enriched content. The Web requires the use of compressed images and limits the amount of special effects you can use. If you burn images to CD or DVD you have more than 4 Gigabytes of space to play with. With that you can produce spectacular presentations. Better still, by burning them to disk in a suitable format you can produce animated slide shows that can be viewed on any domestic DVD player. Like digital cameras, DVD players are enjoying huge sales success, so much of your prospective audience will be able to enjoy your creations.

Apple's iDVD enables you to create dynamic slide shows from your photos, to which music can be added, and even digital video.

THREE-DIMENSIONAL IMAGES

LIKE INFRARED AND PANORAMIC PHOTOGRAPHY, THREE-DIMENSIONALPHOTOGRAPHY PERIODICALLY ENJOYS A SURGE IN POPULARITY. BUT THERE ARE ALWAYS HIGHLY SKILLED DEVOTEES WHO PRODUCE GREAT THREE-DIMENSIONAL IMAGES FOR AN APPRECIATIVE AUDIENCE.

Lenticular stereo images, popularized by cameras made by Nimslo and Nishika, are unique formats which do not require special viewing tools. Today, these are the preserve of specialist photographers.

Two other methods, the anaglyph and twin-image, require special viewing techniques. For anaglyphs you need glasses with a red and a green lens. The anaglyph image features overlapping red- and green-tinted images so that when viewed through the glasses only the image corresponding to each eye can be seen through the lenses. This also produces a monochrome image. Twin-image photos can be color, but need a viewing mechanism that ensures each eye sees only the image corresponding to the view with that eye. For either of these simple techniques the basic production method is the same.

RIGHT
Left- and right-eye images need to be taken consecutively.

ABOVE
Twin-image stereo photos keep the left- and right-eye images distinct.

TUTORIAL
Creating stereo-pan images

1 First take the left shot—this corresponds to the left eye. Take the second shot for the right eye.

2 Once the images are on the computer, open the left view. Enlarge the canvas of this image (Image> Canvas Size) by about 20 percent (this is not critical).

3 Select all in the right eye image. Paste over the left eye and reduce opacity to 50 percent on the Layers palette. Both images will be out of register.

4 Use the Move tool to move the layer (the right eye view) until the subject in it, and the same point in the left eye, coincide precisely.

5 For an anaglyph, desaturate both layers (Image> Adjustments>Desaturate). Select Image> Adjustments>Hue/ Saturation, click on Colorize, and move the Hue slider for the background so the image becomes green. Select the layer and move the slider until the image becomes toned red.

6 For a twin-image photo, crop the image to remove any edges that do not overlap. Increase the canvas size (Image>Canvas Size) to twice the original width, clicking on the left-hand central box in the dialog. Use the Move tool to drag the layer image to the right of the background. The image is ready to be printed and viewed in an appropriate viewer.

MAKING IT BIG

ONE DAY YOU'LL WANT TO MAKE SOME BIG PRINTS FROM YOUR PHOTOS. BUT ENLARGE YOUR DIGITAL PHOTO UP TO EVEN TWICE LEGAL-SIZED PAPER AND YOU'LL BE DISAPPOINTED. HOWEVER, A PLUG-IN CALLED EXTENSIS EMPOWERS YOU TO ENLARGE YOUR IMAGES WITHOUT SACRIFICING QUALITY.

RIGHT
A typical image from a digital camera.

Pxl SmartScale from Extensis is a unique product that plugs in to Photoshop and gives you the power to substantially enlarge your images without limiting quality and scale.

Pxl SmartScale works by using an intelligent interpolation technique. Interpolation, in digital imaging, is the process of inserting new pixels when an image is enlarged. Generally, this is achieved by adding intermediate pixels of average color and tone. These intermediates lead to softening, and the creation of colors and tones that were not present in the original image. The specific algorithms in pxl SmartScale counter this by preserving as much of the original characteristics of the image as possible. The result of this is that you can increase an image size up to 1600 percent.

TUTORIAL
How to make an enlargement

1 Here's a typical image from a digital camera. Looking at it on the printed page, as it might appear when printed to 5x4in, it looks critically sharp.

2 Enlarge the image (Image>Image Size) by eight times and look at a similar-sized area. Can you see that the image quality has been compromised? The image is soft, and the pixel structure is obvious.

3 Use pxl SmartScale to achieve a more credible result that works even in difficult subject areas such as portraits, or with delicate detail.

ENLARGING SMALL IMAGES
If you don't want to invest in pxl SmartScale you can still create convincing big images, simply by being more creative.

■ **Apply an artistic filter.
Applying a Brush Strokes
filter after enlarging will smear
away the pixels or softness.**
■ **Add grain. Used creatively,
grain gives a natural look
to your big prints and hides
artifacts.**
■ **Emphasize the pixel structure
—use the Mozaic filter to
create obvious pixel structure.**

*This close-up shows pixelation
prior to applying the Crosshatch
Brush filter.*

CREATING A WEB PHOTO GALLERY

HAVING AN ONLINE PRESENCE IS BECOMING ESSENTIAL FOR PROFESSIONALS, AND GREAT FUN FOR THE REST OF US. IT LETS FRIENDS AND FAMILY ENJOY PHOTOS OF EVENTS SIMPLY AND CONVENIENTLY. AND YOU HAVE ALL THE TOOLS YOU NEED IN PHOTOSHOP.

TUTORIAL
Creating a web photo gallery

The key to a great website is including only your best images. If you don't rate your photos, visitors won't either. Aim to have 20 great photos rather than 20 great ones competing with 50 average images.

1 Take your finest images and adjust their size. The standard resolution of images viewed on screen is 72dpi so use the Image Size dialog (Image>Image Size) to reduce your images to this resolution. Base the size on the display size for your monitor, and make them 5x7in for optimum downloading speed.

2 To get our image files to the optimum size for the Web we must strike a balance between file-compression and quality. Small files work best on a website but might not be of the highest quality. Conversely, high-quality images take longer to download and can test the patience of visitors to your site. Select File>Save For Web to open the optimizer.

3 It's best to use JPEG High Quality (which should produce a reduction of around 20:1) to retain quality, but if you can get away with more, do so. Every saving in file size represents a saving in your visitors' downloading time. This can make all the difference to the success of a website.

4 Start compiling your web gallery. Select File>Create Web Photo Gallery. In this dialog, specify the folder in which the optimized images are stored, and the folder to which the files to create the web gallery should be written. Type in a site name under the Banner heading.

5 Select a format for the web gallery from the Styles pull-down. There's a wide range from the basic—suitable for any gallery—through to those that are themed for children's photos and holiday snaps.

6 Click OK and wait while your gallery is created. The speed will vary depending on your computer and the number of images. Once complete, your default web browser will be launched and your new gallery displayed.

7 Finally, upload your website using an FTP application. This will be provided by your Internet Service Provider (ISP) or the company that you've chosen to host your web pages.

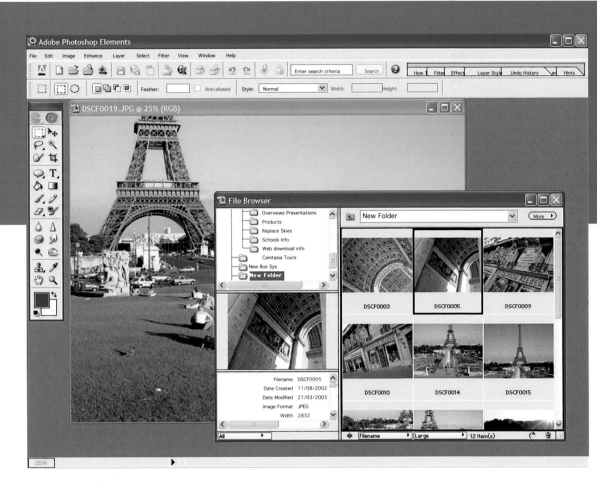

LEFT
*Take one of your best
images and adjust its
size to get it ready for
your Web gallery.*

BELOW LEFT
*It is best to save your
files as JPEGs if you
want to retain quality.*

BELOW RIGHT
Your new gallery!

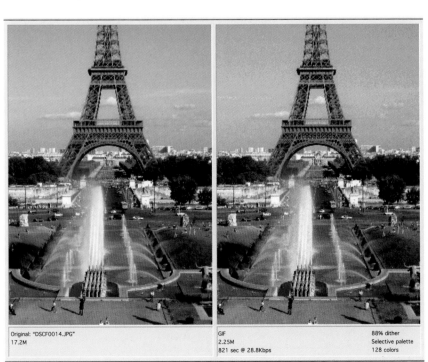

Original: "DSCF0014.JPG"
17.2M

GIF
2.25M
821 sec @ 28.8Kbps

88% dither
Selective palette
128 colors

THE ESSENTIAL GUIDE TO IMAGE CATALOGING

THOSE OF US FOR WHOM PHOTOGRAPHY IS A HOBBY HAVE TO BE ECONOMICAL WITH THE NUMBER OF PHOTOS WE TAKE. AND, ONCE THOSE IMAGES ARE ON THE COMPUTER, THE NUMBER OF IMAGES TENDS TO ESCALATE AS WE APPLY OUR IMAGE-EDITING SKILLS TO SELECTED PHOTOS.

FACING OPPOSITE
Photoshop Album is a simple, but remarkably effective, way of keeping track of your images.

In the days when photos were arranged in albums, and corresponding negatives or transparencies in their own storage, it was comparatively simple to keep track of images, but with digital images it can potentially be a big problem.

It makes sense to catalog all your images. Catalogs not only give you an overview of your images but, as your collection grows, will let you search your image collection for specific images by subject. Catalogs also advise you on where to find certain images, whether they are stored locally on your computer's hard disk or have been safely backed-up onto a CD-ROM or DVD. For many of us, the process of cataloging images is one we approach with dread. We'd rather be taking photos than filing them. Thus, any product that can take away this tedium is to be cherished. One such product is Photoshop Album. Album takes care of the downloading. As the download progresses, images are stored away and filed according to the date on which they were taken, automatically creating a cataloging regime. You can add additional keyword tags for performing more rigorous searches. Add simple tag terms such as "vacation", "travel", "landscape" and "Montana", and hunting down that vacation shot of Montana landscape will become simple.

Usefully, Photoshop Album also features a timeline and calendar that show the number of photos taken on different dates. Switch to Calendar mode and you can review thumbnails of images taken on those dates—ideal for occasions when your cataloging by keyword hasn't been precise.

IPHOTO
Photoshop Album is a Windows-only product, but Mac users can use a very similar product called iPhoto. It includes cataloging and album-filing options, along with the opportunity to produce real photo albums and movie showreels (using iMovie) from selected images.

RIGHT
iPhoto is a similar offering to Photoshop Album but is included free as part of the Mac operating system.

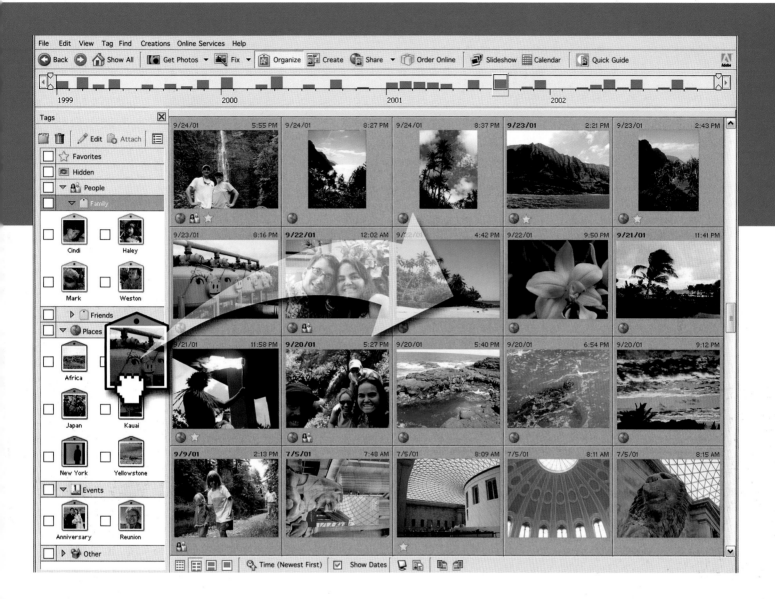

POWER ARCHIVING

If you're serious about your photography then you might need something more powerful than Album. For many, the solution to cataloging really big collections is Extensis Portfolio. It is to the cataloging world what Photoshop is to digital imaging. Portfolio has incredible storage and retrieval facilities but, like Photoshop, is packed with features and functionality which can be overwhelming for the beginner.

RIGHT
Extensis Portfolio is the standard in professional and enthusiast image-cataloging.

09

RESOURCES

Once you start editing and manipulating your images you'll find it very hard to stop. We hope that this book provides you with the inspiration and guidance to help you take your first steps into this compelling world.

In this section you'll find further sources of information and inspiration. For those of you who have Photoshop Elements—or perhaps are using an alternate photo-editing application, we've provided a comparison table showing the features offered by a range of applications. You'll be able to check

We've also included a section on Photoshop shortcuts. Many of the commands that you've come to love can be accessed by using simple keystrokes or key combinations. Learn just a few and you'll find you'll be working more effectively.

There's no doubt that the Web offers a great

IMAGE-MANIPULATION GLOSSARY

Airbrush tool
The image-editing equivalent of the artist's airbrush. In recent versions of Photoshop it's offered as a variation of the Paintbrush tool (rather than a stand-alone tool). It sprays a soft-edged line with the foreground color, with the size and opacity determined by the brush and opacity settings respectively.

Aliased, anti-aliased
A rough, jagged edge which appears when curved and diagonal lines are reproduced on a computer screen and subsequently printed. Due to the pixel-based composition of digital images, those affected in this way are described as aliased. Algorithmic smoothing techniques (described as "anti-aliasing") introduce intermediate color pixels to smooth transitions.

Alpha channel
A channel used in Photoshop (and other image-editing applications) to store selection information. When a selection is stored as an alpha channel it can be recalled later for reuse, unlike a conventional selection, which is lost when an image is closed. An alpha channel will appear in the Channels palette below the conventional channels for that image. Creating alpha channels is a good way to save time re-selecting complex elements in an image.

Artistic filters
A discrete group of filters in Photoshop designed to apply artistic or painterly effects to images. Artistic effects are also possible using filters from some of the other groups, especially Brush Strokes.

Background color
The color revealed when image elements are removed from a scene and the end point of the default color gradient. Foreground and background colors can be reversed by clicking on the button to the top right or returned to black (the default) by clicking on the black-and-white icon.

Banding
A defect sometimes seen in printed output due to a printer's inability to accommodate intermediate colors or due to posterization.

Bezier curve
A line described by a math equation that is used to create and define paths. The path line can be manipulated so as to precisely follow an object's boundary by manipulating anchor point handles that are manually and automatically added to any path.

Bit depth
Also known as bits per pixel. A value that determines the color (or gray) value of an image. The greater the bit depth, the more grays (and colors) that define the total number of colors in the image.

Bitmapped
(1) An image (typically a photograph) in which every pixel is described by a numeric value given by the bit depth. As such, it is distinguished from, for example, vector graphics where every point has a continuously varying value.

(2) An image with a bit depth of 1. Every pixel is described by a 1 or 0 and the image comprises only pure white and pure black.

Blur filters
Filters designed to unfocus an image or image selection or to impart motion and dynamic effects. Blur and Blur More filters apply a simple blurring effect throughout the image or selection. The Gaussian Blur filter gives a more controlled blurring while Motion and Radial Blur filters can be used to create the effect of linear motion, zooming, and rotation.

Brush
A definition of the size and shape of the painting effect employed by a painting tool such as the Airbrush or Paintbrush.

Brush Strokes
A Photoshop filter set that emulates brush and drawing techniques.

Channel

Constituent of an image represented as a Grayscale image of that image illuminated in one color light. An RGB image will include Red, Green, and Blue channels. Additional Alpha Channels are sometimes included.

Clipboard

Area of temporary storage in a computer's memory designed to hold image selections made using the Cut or Copy commands.

Clone tool

Generic name for the tool dubbed the Rubber Stamp tool in Photoshop.

Color swatches

A set of colors that can be used for painting. They can comprise pre-set colors, or include colors used regularly by the user and sampled using the Eyedropper tool. Usually collected together in a palette.

Crop tool

Selection tool used to define a desired area within an image. With cropping, the extraneous parts are discarded. A variation, the Perspective Crop, enables perspective modification in an image.

Curves

A mapping of the input values of brightness color to the output values. By changing the shape of this Curve (from the direct, 1:1 correspondence), selected tones in the image can be altered, made brighter, darker, or inverted. Used for precise corrections and abstract effects such as Sabattier.

Eraser tool

Tool which is used to erase parts of an image. Depending on the mode selected this can comprise all underlying pixels, those in a particular layer, or of a predetermined quality.

Eyedropper tool

Tool that can be used to sample a specific color in an image. Once sampled, that color becomes the current foreground color and could optionally be saved as a color swatch.

Fill tool

Sometimes called the Paint Bucket, this tool is used to flood a selection with the current foreground color.

Foreground color

The color used to paint with when a painting tool is selected.

Gaussian Blur filter

One of the Blur filter group used where a uniform, but controlled, amount of blurring is required. Fine and coarse settings make it possible to impart almost any amount of unsharpness to an image.

GIF format

A file format principally used to save graphic files used on the Web.

Gradient tool

A tool enabling a smooth transition between at least two colors or one color and transparency. Normally a gradient is created between the foreground and background colors.

Grayscale

A color mode that displays an image in black, white, and 254 intermediate shades of gray.

Handles

Small boxes found at the corners and midpoints of the sides of selections. Depending on the feature, these can be used for resizing, distorting, or rotating the selection.

Heal and Patch tool
Tool introduced with Photoshop 7 that enables complex cloning. Areas can be repaired by selecting and dragging a region nearby. The texture of the patch is retained and combined with the coloration and light levels of the original area.

Hue/Saturation
Command used to alter the hue (color) of an image and the saturation (intensity of the color).

Image optimization
A process used to reduce an image file size while maintaining quality. Generally used when preparing images to be sent by email, or used on a web page when file size is of particular significance.

JPEG format
File format used for saving image files, notable for its ability to compress images. Compressed images do, however, suffer from artifacts and degradation.

Layer
A virtual plane in an image that can be painted on or manipulated without affecting those above or below. Specialized layers are transparent, but modify the underlying layers in terms of color, contrast, and other variables.

Layer Mask
Mask applied to a layer to alter the visibility of that layer and the background image. By painting on the mask in black or white (or intermediate grays where transparency is required), parts of the layer image can be hidden or revealed.

Marquee tool
Selection tool that bases the selection on regular rectangular, elliptical, or other regular geometric forms.

Mask
A term derived from the printing industry that describes a coating applied to an area of an image to prevent manipulations and edits affecting it; more generally an area of an image that is not actively selected is often regarded as masked. In Photoshop Layer Masks and QuickMasks are offered.

Move tool
Tool used to move a selection to a new position or move the contents of a layer relative to the contents of other layers.

Object
See layers.

Opacity
See also Transparency. A feature of layers and effects that enables them to be rendered opaque or transparent (and usually expressed as a percentage).

Palette
An interface element that contains controls or settings for a tool or command. Unlike dialog boxes that appear only when needed, palettes are usually visible continuously (subject to context and whether a Show/Hide Palette command has been used). Palettes can often be moved freely around the screen or "docked" conveniently.

Path
A line drawn with the Pen tool that can be used to describe object and selection boundaries. Closed paths can be turned into selections. The reverse is also true.

Pen tool
Tool used to describe a path. See above.

Perspective Crop
A variation on the Crop tool that enables perspective effects to be corrected when the image is cropped. The crop is defined along the axes of the convergence and the crop actioned; the image is then rescaled to account for the changes in linearity.

Pixel
Fundamental component of a digital image.

Plug-in
Description of a small program designed to integrate seamlessly with a host application. Usually used to denote filter programs that can be slotted into Photoshop and Photoshop Elements for added creativity.

Posterization
Process in which the number of tones in an image is reduced. Color gradients are reduced to bands of even color. Usually used for graphic effect.

QuickMask
A mask applied using painting tools to aid object selection.

Rubber Stamp tool
Tool used to clone parts of an image (or an entirely different image) over other pixels in the image. Used to hide or disguise unsightly marks, unwanted elements, or add new details (such as additional people to a group).

Sabattier effect
A traditional darkroom effect achieved by exposing film emulsion to light so that certain tones become reversed. It is recreated in the digital darkroom by altering the curve graph in the Curves dialog.

Selection
An area of an image (that can be the entire image) on which manipulations, edits, and transformations can take place. It is the active area. Areas outside the selection are described as unselected or masked.

Sharpening filters
Set of filters designed to increase the perceived sharpness in an image. While no filter can make good poor focus and unsharp lenses, each of the filters in this group can enhance the image to give the effect (when viewed from a suitable distance) that the image is sharp. Unsharp Mask is, arguably, the most effective filter.

Stroke
When an object selection is stroked a line is applied to the selection boundary (color and thickness can be user determined).

Transparency
See Opacity.

Unsharp Mask
A sharpening filter that uses three parameters (Amount, Radius, and Threshold) to give a very precise amount of sharpening to an image. By careful manipulation of the parameters a sharpening effect perfectly matched to the subject can be achieved.

Vector image
Images comprising vector elements (i.e. those determined by mathematical expressions rather than pixels). Vector images can be rescaled without affecting resolution (if pixel images are enlarged the pixel nature becomes obvious).

IMAGE-EDITING PROGRAMS

WITH THE RANGE OF IMAGE-MANIPULATION SOFTWARE PACKAGES ON THE MARKET, TRYING TO MAKE SENSE OF THE DIFFERENCES BETWEEN THEM CAN BE DAZZLING. THIS HANDY REFERENCE WILL HELP YOU MAKE SENSE OF EXACTLY WHAT THEY CAN DO FOR YOU.

Application type	Photoshop Image Editor	Photoshop Elements Image Editor	
Advanced color-correction controls	*	*	
Advanced painting tools and control	*		
Batch-processing commands and script generation	*	*	
Color cast quick-fix tool	*	*	
Color-separation creation and printing	*		
Compatible with Photoshop plug-ins	*	*	
Compound Selection tools	*	*	
Convergence/Perspective correction	*	*	
EasyPalette drag-and-drop effects			
Embedded copyright information	*	*	
Full-color management	*		
Histogram, Levels, and Curves	*	*	
History palette/multiple undo	*	*	
Image annotation	*		
Image-element extraction	*	*	
Image or File Browser	*	*	
Image spraying			
Import/Export of Web (GIF, JPEG, and PNG) files	*	*	
Layer Blend modes	*	*	
Layer styles	*	*	
Layers/Objects	*	*	
Lighting Effects	*	*	
Magnetic selection tools	*	*	
Masks and Channels	*	*	
Mesh warp/Freeform distortion tools	*	*	
Multiple color modes	*		
Natural media paint effects	*		
Output to Photoshop-compatible file format	n/a	*	
Panorama creation (stitching) features	*	*	
Paths	*		
Quick Fix/Auto Enhance features	*	*	
Real-time rendering/previewing	*	*	
Retouching tools	*	*	
Slice tools	*		
Special effects filters	*	*	
Spot-color channels	*		
Text tools (including type manipulation)	*	*	
Transformations and 3D Transformations	*	*	
Vector shapes/graphics	*	*	
Web image optimization	*	*	
Webpage/Webpage elements/HTML generation	*	*	

	Paintshop Pro Image Editor	Photo-Paint Image Editor	Painter Painting	PhotoImpact Image Editor	Canvas Image Editor & Illustration
	*	*	*	*	*
	*	*	*	*	*
	*	*	*	*	*
			*		
	*	*	*		*
	*	*	*	*	*
	*	*	*	*	*
	*	*	*	*	
			*		
	*	*	*	*	*
	*	*	*	*	*
	*	*	*	*	*
	*	*	*	*	*
	*	*	*		
				*	*
	*	*		*	*
	*	*	*	*	*
	*	*	*	*	*
	*	*		*	*
		*	*	*	*
	*	*	*	*	*
	*	*	*	*	*
	*	*		*	*
	*	*	*	*	*
	*	*	*	*	*
	*	*			*
			*		*
	*	*	*	*	*
		*		*	
	*	*	*		*
	*		*	*	*
	*		*	*	*
	*		*	*	*
	*	*	*	*	*
		*	*		*
	*	*	*	*	*
		*		*	*
	*	*	*	*	*
	*	*			
	*	*		*	*

TOOLS AND FUNCTIONS

AFTER MANY YEARS YOU WILL KNOW THE VARIOUS FUNCTIONS FOR PERFORMING
MANIPULATIONS BY HEART, BUT, UNTIL THEN, THIS EASY-REFERENCE TABLE WILL BE INVALUABLE.

TOOL	PS7	PE2	FUNCTION	NO. OF OPTIONS	HOW TO USE
Marquee	1	1	Selection tool	4	Click and drag to surround the area to be highlighted.
Lasso	2	2	Selection tool	3	Each click defines a point on the outside of the area to be selected. Click back on the first point to complete the selection.
Crop	3	15	Canvas tool	1	Click and drag then release to complete definition of crop area. Click to enforce action. Reduces Canvas size to cropped area.
Healing brush	4	N/A	Retouching tool	2	Use to repair damaged areas by "smart" copying of selected pixels elsewhere.
Clone stamp	5	11	Retouching tool	2	Copies pixels from one part of an image to another. Very useful for repairing images.
Eraser	6	7	Retouching tool	3	Click and hold on the area to be erased and rub away, like with an eraser.
Blur	7	8, 9, 21	Retouching tool	3	Use like an eraser. Smoothes pixels over, blurs details.
Path selection	8	N/A	Masking tool	2	Click on a path point to select it and alter its shape
Pen	9	N/A	Masking tool	5	Draws paths to mask all but the shape you've drawn from the layer below.
Notes	10	N/A	For adding notes	2	Add written "stickies" or voice annotation to your images.
Hand	11	12	Navigation	1	When the image is magnified, it all won't fit on screen at once, and the hand tool lets you move the image around.
Move	12	13	Moving tool	1	Lets you move whole layers or selected areas of the image around.
Magic Wand	13	14	Selection tool	1	Selects areas of the same (or similar) tonal values as those clicked upon. You can adjust the similarity of tonal values from exactly the same to virtually everything.
Slice	14	N/A	Web art tool	2	Used to create slices for Internet graphics.
Pencil	15	18, 6	Drawing tool	3	For drawing in fine detail or freehand designs.

History Brush	16	N/A	Selective Undo	2	Allows you to put back detail removed in earlier manipulation since document was opened within the limits of the number of history levels set in Preferences.
Gradient	17	17	Painting tool	6	Allows a graduated fill in one of six patterns. When used with QuickMask also acts as a very flexible selection tool.
Burn tool	18	22, 9,10	Levels control	3	In Photoshop this tool also contains the Dodging and Sponge tools. Used to control local exposure just as in a darkroom.
Type	19	16	Adding text	4	Lets you add text to documents
Shape tool	20	4	Adding shapes	6	Lets you draw scaleable, editable shapes of any color or border
Eyedropper	21	23	Colour measuring	3	Click on any pixel to copy its color to the foreground color box.
Magnifier	22	24	Zooming in or out	1	Lets you view images much magnified or reduced. Very useful for close-up retouching.
Selection Brush	n/a	3	Selection tool	1	Lets you select parts of an image by painting them.
Redeye Brush	n/a	19	Retouching tool	1	Allows you to remove red eye from portraits quickly and easily.
Paint Bucket	(17)	5	Painting tool	1	Fills selected area or whole canvas if nothing selected.
Colors box	A	A	Color changing	N/A	Clicking on the top left-hand box allows you to change the foreground color, on the bottom right box to change the background color. Clicking on the smaller black-and-white overlapping boxes re-sets the colors to the default black/white combination. Clicking the double-ended arrow swaps the foreground and background colors.
QuickMask mode	B	N/A	Masking	N/A	Lets you switch between QuickMask and normal standard mode.
Screen mode	C	N/A	Viewing preference	3	Allows you to see all documents at once, one document with only the menu bar, or just one document on a black background.
ImageReady	D	N/A	Launch Web program	1	Launches ImageReady. Photoshop 7's companion program for optimizing images for the Web.

KEYBOARD SHORTCUTS

WITH DIGITAL IMAGING YOU'LL BE CONSTANTLY MOVING YOUR MOUSE. MUCH OF THIS IS ESSENTIAL: DRAGGING ACROSS SELECTIONS, DRAWING GRADIENTS, ETC., BUT MANY SELECTIONS—CHOOSING A NEW TOOL OR ACCESSING A MENU OPTION—CAN BE ACHIEVED WITH A FEW KEYSTROKES.

OPERATION	MACINTOSH	PC
Help features		
Help Contents		F1
Help, context-sensitive	Shift + F1	
Toolbar tools		
Display Crosshair Cursor	Caps Lock	Caps Lock
Display Options palette	Return	Enter
Edit Brush Shape	Double-click Brush Shape	Double-click Brush Shape
Paint or Edit in a straight line	Click and then Shift + Click	Click and then Shift + Click
Reset to Normal Brush Mode	Shift + Option + N	Shift + Alt + N
Restore image with Magic Eraser	Option + drag with Eraser	Alt + drag with Eraser
Paintbrush	B	B
Pencil	B	B
Marquee	M	M
Move	V	V
Lasso	L	L
Magnetic Wand	W	W
Crop	C	C
Slice	K	K
Healing Brush/Patch	J	J
Clone/Stamp	S	S
History Brush	Y	Y
Eraser	E	E

Paint Bucket/Gradient	G	G
Blur/Sharpen/Smudge	R	R
Dodge/Burn/Sponge	O	O
Path tools	A	A
Type	T	T
Pen tools	P	P
Line/Vector Shapes	U	U
Notes	N	N
Eyedropper/Measure	J	J
Hand	H	H
Zoom	Z	Z
Display or Hide Brushes palette	F5	F5
Display or Hide Color palette	F6	F6
Display or Hide Layers palette	F7	F7
Display or Hide Info palette	F8	F8
Display or Hide Actions palette	F9	F9
Image Size	F11	F11
Revert to Saved	F12	F12
Menu commands		
Auto Levels	Cmd + Shift + L	Ctrl + Shift+ L
Color Balance	Cmd + B	Ctrl + B
Color Balance, use previous settings	Cmd + Option + B	Ctrl + Alt+ B
Copy	Cmd C + or F3	Ctrl + C or F3

Curves	Cmd + M	Ctrl + M		Print	Cmd + P	Ctrl + P
Cut	Cmd + X or F2	Ctrl + X or F2		Quit	Cmd + Q	
Desaturate	Cmd + Shift + U	Ctrl + Shift + U		Redo	Cmd + Z	Ctrl + Z
Fade Filter	Cmd + Shift + F	Ctrl + Shift + F		Reselect	Cmd + Shift + D	Ctrl + Shift + D
Feather selection	Cmd + Option + D or Shift + F6	Ctrl + Alt + D or Shift + F6		Save	Cmd + S	Ctrl + S
Fill	Shift + Delete or Shift + F5	Shift + Backspace or Shift + F5		Save As a Copy	Cmd + Option + S	Ctrl + Alt + S
Filter, repeat last	Cmd + F	Ctrl + F		Save As	Cmd + Shift + S	Ctrl + Shift + S
Filter, repeat with new settings	Cmd + Option + F	Ctrl + Alt + F		Select All	Cmd + A	Ctrl + A
Free Transform	Cmd + T	Ctrl + T		Select None	Cmd + D	Ctrl + D
Display or Hide Grid	Cmd + Quote (")	Ctrl + quote (")		Step Backward	Cmd + Option + Z	Ctrl + Alt + Z
Group with Previous Layer	Cmd + G	Ctrl + G		Step Forward	Cmd + Shift + Z	Ctrl + Shift + Z
Display or Hide Guides	Cmd + Semicolon (;)	Ctrl + semicolon (;)		Zoom In	Cmd + Plus (+)	Ctrl + Plus (+)
Hide Edges	Cmd + H	Ctrl + H		Zoom Out	Cmd + Minus (-)	Ctrl + Minus (-)

Other useful and popular shortcuts

Add to selection	Shift Drag or Shift Click with selection tool	Shift + Drag or Shift+ Click with selection tool
Delete last point added with Magnetic Lasso tool	Delete	Backspace
Hide or show Marquee	Cmd + H	Ctrl + H
Move Marquee as you draw it	Spacebar	Spacebar
Paste image behind selection	Cmd + Shift + Option + V	Ctrl + Shift + Alt + V
Paste image into selection	Cmd + Shift + V	Ctrl + Shift + V
Reselect after Deselect	Cmd + Shift + D	Ctrl + Shift + D
Reverse selection	Cmd + Shift + I or Shift + F7	Ctrl + Shift + I or Shift + F7
Cancel Crop	Press Escape	Press Escape
Cancel Transformation	Press Escape	Press Escape



Hue/Saturation	Cmd + U	Ctrl + U
Hue/Saturation, with last settings	Cmd + Option + U	Ctrl + Alt + U
Inverse Selection	Cmd + Shift + I or Shift + F7	Ctrl + Shift + I or Shift + F7
Invert	Cmd + I	Ctrl + I
Levels	Cmd + L	Ctrl + L
New File	Cmd + N	Ctrl + N
New Layer	Cmd + Shift + N	Ctrl + Shift + N
Open	Cmd + O	Ctrl + O
Page Setup	Cmd + Shift + P	Ctrl + Shift + P
Paste	Cmd + V or F4	Ctrl + V or F4
Paste Into	Cmd + Shift + V	Ctrl + Shift + V
Preferences	Cmd + K	Ctrl + K

Display or Hide grid	Cmd + Quote (")	Ctrl + Quote (")
Display or Hide guides	Cmd + Semicolon (;)	Ctrl + semicolon (;)
Display or Hide rulers	Cmd + R	Ctrl + R
Lock or Unlock guides	Cmd + Option + Semicolon (;)	Ctrl + Alt + semicolon (;)
Select Measure tool	Press U	Press U
Snap guide to Ruler tick marks	Press Shift while dragging guide	Press Shift while dragging guide
Toggle grid magnetism	Cmd + Shift + Quote (")	Ctrl + Shift + Quote (")
Toggle Horizontal guide to Vertical or vice versa	Press Option while dragging guide	Press Alt while dragging guide
Repeat Filter with last settings	Cmd + F	Ctrl + F
Repeat Filter with different settings	Cmd + Option + F	Ctrl + Alt + F

SHORTCUT NIRVANA

Talk to a seasoned Photoshop professional and they'll tell you how much their productivity is boosted by using keyboard shortcuts. Some of these shortcuts (for example pressing "L" to make the Lasso the active tool or "E" for the Eraser) are easy to remember, but many are a little more obscure. You'll find a selection of these on pages 170–172, but how about this for a neat solution and an *aide-memoire*?

Logickeyboard (www.logickeyboard.com) offers a simple but effective Photoshop keyboard. Color-coordinated keys indicate shortcuts, extra functions, and even the original key character. Keyboards are available in PC and Mac versions (the latter using a genuine Apple Pro keyboard) and also as sets of replacement keys to customize your own keyboard.

BIBLIOGRAPHY

THE INTERNET IS A DYNAMIC MEDIUM. OCCASIONALLY, WEBSITE ADDRESSES CHANGE, WEBSITES CLOSE DOWN, AND OTHERS APPEAR. THE INFORMATION HERE WAS VERIFIED AT THE TIME OF GOING TO PRESS.

Information and resources

www.adobe.com
Support, information, and news from Photoshop's parent website. (Go there direct from Photoshop by clicking on the top of the toolbox.)

www.ephotozine.com
Technique, news, reviews, and more from the UK's premier photographic resource site designed for conventional and digital photographers along with those with any kind of darkroom.

www.extensis.com
Home site for Extensis products, including cataloging application Portfolio, pxlSmartScale, and more. Lots of useful tips and hints, too.

www.photo.net
General discussion forums, news, equipment reviews, portfolios, and techniques.

www.steves-digicams.com
Fantastic resource for all things digital photography. Especially strong on cameras but lots of collateral, software reviews, and links to software and info sites.

www.totaldp.com
Website that supports the digital photography magazine, *Total Digital Photography*. Includes original images from the magazine so you can follow through the tutorial and step-by-step work.

www.panoguide.com
Bitten by the bug for panoramic photography? Here's everything you need to know, from specialist cameras, panoramic mounts for tripods, through to software applications. There are plenty of FAQs, too.

www.photoshopworld.com
Website for the annual conference and expo on all things Photoshop. Want to meet your Photoshop gurus and mentors? This is the place!

Applications websites

www.adobe.com: Photoshop's homepage
www.corel.com: PhotoPaint, CorelDraw, and Painter
www.jasc.com: Paint Shop Pro
www.ulead.com: PhotoImpact and PhotoExpress
www.roxio.com: PhotoSuite and CD-burning Applications
www.iseemedia.com: Photovista Panoramic Software and panorama resources
www.realviz.com: Stitcher and Stitcher EZ Panoramic applications
www.alienskin.com: Eye Candy and Xenofex plug-ins
www.andromeda.com: Plug-ins
www.flamingpear.com: Plug-ins
www.xaostools.com: Plug-ins

INDEX

A

adding definition 88
adding elements 50–51, 68–9
adding emphasis 70–71
adjustment layers 100
Adobe Photoshop 6, 17, 22
advertising 140
Airbrush tool 162
aliased 162
Alien Skin Software 119
Alpha channel 162
anaglyphs 152, 153
animated slide shows 151
anti-aliased 162
antiquing images 94–5
Apple 143
applications software 17
architectural shots 82
archiving 159
ArcSoft 140, 142
artistic filters 133, 162
Autotools 44, 46

B

background 110–11, 162
 blurring 103, 123
 changing 105, 108–9
 editing 58
backlighting 56
balancing elements using
QuickMask 62
banding 162
Bezier curve 162
bit depth (bits per pixel) 162
bitmapped 162
black-and-white images 96–7
blemishes 52–3
blend modes 110–11, 112–13
blur 32, 90
blur filters 122–3, 162
BoxTop 148
Brightness/contrast 43, 44
broadband 148
brush 162
brush strokes 155, 162

C

camera shake 26
captions 130
caricatures 141
cataloging images 20–21, 158–9
CCDs 12, 26
CD-ROM 158
CD writer/reader 16
CDs 151
channel 163
Channel Mixer 136–7
Charge Coupled Devices (see CCDs)
clip-art library 68
Clipboard 163
Clone tool 50–51, 52, 54–5, 93, 163
color 10, 12–13, 76–7
 adding 96
 correcting 33
 enhancing 120
color balance 27, 28, 44
color fidelity 148
color infrared 137
color management 148
color range 35
 selecting 40
color swatches 163
Colored Pencil 116–17
columns 10
composition 54
computer platforms 7
computer requirements 16
configuring the computer 34
contrast 27, 44, 46, 47, 48, 62, 74–5, 93
 portraits 88
 reducing 139
converging verticals 82
copying subject into
new image 104
Craquelure Effect 85
cropping 82–3, 163
Crystallize 116–17
Curves 48–9, 163

D

data compression 22, 148, 150
data loss 23, 32
daylight 13
defects 162
depth of field 71, 122
desaturation for emphasis 71
desktop publishing 130
detail 32
Diffuse Glow 116–17
digital artifacts 120
digital video cameras 142
digitization 14
Dodge tool 87
dodging and burning 74–5
dots per inch (see dpi)
downloading images 21
dpi 24
duotone effect 138–9
Dust and Scratches
filters 52, 53
DV (see digital video)
DVDs 151, 158

E

email output 148, 150
Emboss 116–17
emphasis 70–71
enlargements 154–5
Eraser tool 163
EXIF data 22
exposure correcting 27, 33
 with Autotools 44–5
 with Blend mode 112–13
 with Curves 48–9
 with Levels 46–7
 with Masks 56–7
Extensis 154
Extensis Portfolio 159
extra information data (see EXIF data)
Extract tool 108–9
Extrude 116–17
Eye Candy 119
Eyedropper tool 163

F

false color effects 137
Feather tool 108
feathering 40, 41, 58–9
file formats 22–3
Fill tool 163
film scanners 18
filter effects 116–17
filters 27, 84–5
Flaming Pear 134
flash images
 improving 112
flatbed scanners 18
Flood filter 119
fluorescent light 13
focus 63, 122
foreground color 163
Fujifilm 142

G

gamut 35, 148
Gaussian blur filter 84, 103, 120, 122, 163
GIF format 163
Gradient tool 62–3, 163
grain 84–5, 155
Graphic Pen 116–17, 135
graphics card 16
Gray Point 88
Grayscale 163
gum dichromate look 128–9

H

hand drawn look 135
Handles 163
handtinting black-and-white
images 96
hard disk 16, 34
hard disk space 34
Heal and Patch tool 50, 164
heirloom photos (see old photographs)
high-key 88
highlights 49, 75

histograms 46
History tool 64
hue 76
Hue/Saturation 164
humor 141

I

icons 36, 101
image browser 20
image editing software 17, 166–7
image manipulation possibilities 32
image optimization 164
image quality 14, 26–9
 compression 23, 50, 156
image size 28, 148, 156
immersive montage 106–7
iMovie 3 143
India Ink 134
indistinct edges 108
infrared film effect 136–7
ink 146
ink-jet printers 1 8, 24, 146
inputting 20
inserting objects 107
Internet Service Provider (see ISP)
interpolation 28, 154
inverting a selection 40, 41
isolating objects 68–9
ISP 156

J

Joint Photographic Experts Group (see JPEG)
JPEG format 22, 149, 150, 156, 157, 164

L

labeling files 20
landscape photography 136
Lasso 39, 41, 70
Layer Masks 100, 106–7, 164

Layers 50, 100–113, 164
lens quality 26
lenticular stereo images 152
Levels 46–7
low-key 8 8

M

M603 camera 142
Macintosh OS 17
Magic Wand 38
manual option white balance 13
Marquee tool 38, 164
Masks 56–7, 164
memory cards 22
micro images 140
modifying a selection 40
monochrome (see also black-and-white) 77
montage 68, 102–5
motion
 enhancing 122, 125
Move tool 164
movie mode 142
moving elements 61
Mosaic filter 155

N

newsletters 130
Nimslo 152
Nishika 152
noise 69, 84
Nyquist frequency 26

O

object 164
old photographs 33, 45
 restoring 93
Opacity 164
operating software 17
original images 23
output options 146–7
oversampling 26

P

Palette 164
panoramas 17, 80–81
path 164
Pen tool 164
perspective 82–3
Perspective Crop 164
photo-processors 25
photo-tapestries 140
photographic paper 18, 25, 146
Photomerge 80
PhotoMontage 140
Photoshop Album 158
Photoshop document format (see PSD format)
Photoshop Elements 17
PhotoVista 81
pixel structure 15, 155
pixellation 14
pixels 10, 35, 165
Plastic Wrap 116–17
plug-ins 34, 118–19, 165
portraits 49, 84
 high-key 88–9
 improving 86–7, 112, 113, 121
 low-key 88
 soft-focus 90–91
Poster Edges 116–17
posterization 23, 165
PowerGoo 141
previews 148
print quality 18, 24
print scanners 18
printer settings 146
printing 18, 24–5, 146–7
profiles 148
ProJpeg 148
PSD format 22
Pxl SmartScale 154

Q

QuickMask 60–61, 62–3, 165

R

Radial Blur filter 122, 123–5
RAM memory 16, 34
RAW mode 22
reflection
 replacing 67
removing elements 41, 50–51, 54–5
 random blemishes 52–3
resizing 68, 69, 149
resolution 14, 15, 26, 142, 156
restoring old photos 92–3
reversing an image 102–3
Rough Pastels 116–17
rows 10
Roxio Photosuite 81
Rubber Stamp tool 165

S

Sabatier effect 79, 165
saturation 76, 120
saving files 22
saving images 32
saving selections 64–5
scanners 18
scanning 12, 26
scrapbooks 141
Scratch disks 34
selecting part of an image
 basic 38–9
 complex 40–41
selections 162, 165
 saving 64–5
sepia-toned photographs 76, 94
shadows
 creating 61, 103
shareware 118
sharpening filters 165
sharpness 28, 93
 using QuickMask 62
shortcuts 170–72
sky 66–7
sky and foreground contrast 62, 74

soft-focus 87, 90–91, 136
software 17
software versions 7
solarization 78
sparkling eyes 86, 87
Spin blur 124
splitting channels 95
stereo-pan images 153
still photos to movies 143
stroke 165
subject movement 26
sunsets 13

T

Tagged Image File Format
 (see TIFF)
text 130–31, 132
text layers 100, 130
text masks 131
texture 85
35mm slides 18
three-dimensional photography
 152–3
thumbnails 20, 140, 149, 158
TIFF 22, 150
tonal range (see contrast)
toning 94
toolbar 36
tools 36-7, 168–9
transparency 165
twin-image photos 152, 153

U

underexposure (see exposure)
units 35
Unsharp Coloration 120–21
Unsharp Mask 165
USB connection 16

V

vector image 165
video clips 142
VideoImpression 142
vignettes 70, 94

W

Water Paper 116–17
web output 149
web photo gallery 156–7
website creation 17
white balance 13
wide-angle views 80
Windows 17
woodcut effect 134
words (see text)

X

Xenofex 119

Z

Zoom blur 124
zoom lenses 80
zooming 71